IMAGES
of America

EARLY KANSAS CITY,
MISSOURI

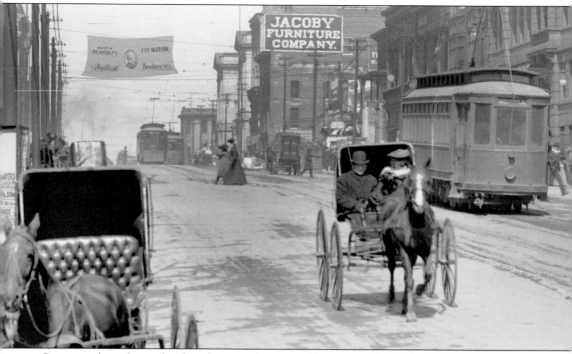

Streetcars share the road with pedestrians, horses, and buggies on Grand Avenue in 1908. (Vintage Kansas City Image Vault.)

ON THE COVER: Kansas City's River Market stands at the location where the town of Kansas began in the 1830s, as shown in this 1906 photograph, and as it remains to this day. (Library of Congress.)

IMAGES
of America

EARLY KANSAS CITY, MISSOURI

Leigh Ann Little and John M. Olinskey

ARCADIA
PUBLISHING

Copyright © 2013 by Leigh Ann Little and John M. Olinskey
ISBN 978-0-7385-9096-7

Published by Arcadia Publishing
Charleston, South Carolina

Printed in the United States of America

Library of Congress Control Number: 2012953160

For all general information, please contact Arcadia Publishing:
Telephone 843-853-2070
Fax 843-853-0044
E-mail sales@arcadiapublishing.com
For customer service and orders:
Toll-Free 1-888-313-2665

Visit us on the Internet at www.arcadiapublishing.com

In loving memory of Anthony Benkovich who, like all of the people you'll meet in this book, will forever be a part of Kansas City.

CONTENTS

Acknowledgments 6

Introduction 7

1. Europeans Arrive 9

2. Town of Kansas 19

3. The Civil War 33

4. Peace and Progress 41

5. A City Beautiful 75

6. Changing Centuries 101

ACKNOWLEDGMENTS

The authors are indebted to Kansas City's many historians who strive every day to keep the history of this town alive. The workers, volunteers, and benefactors of the John Wornall House, the Alexander Majors House, the Westport Historical Society, the Kansas City Missouri Public Library, the Jackson County Historical Society, the Midwest Genealogy Center, the Historic Kansas City Foundation, the Bingham-Waggoner Estate, the Nelson-Atkins Museum of Art, and countless other local organizations work tirelessly to preserve the memory and culture of this unique and truly American city. We owe an even greater debt to historians of the past, who took the care to preserve and archive the records and stories that made this pictorial history possible.

We would also like to offer thanks to Tony Botello, Meesha Viron, David Remley, Xavier Onassis, Eric Bowers, and many others, who daily and weekly are creating the narrative and images of Kansas City life today that future historians will draw upon to understand what living in our town was like in this day and age.

Special thanks go to Bill Osment, for his years of assisting us in our historical adventures, and to David Billikopf, for his generosity and inspiration.

The Goodwill Industries of Greater Kansas City and the Truman Medical Center not only helped us by contributing interesting photographs for this project, but they also help thousands of Kansas City area residents every day to overcome obstacles and improve the quality of their lives. Our gratitude to them and the many organizations that provide care for the people of this town is boundless.

We will forever be thankful for Arcadia Publishing for giving us the opportunity to share these images and stories, with extra special thanks to Liz Gurley, without whose help and patience this book would not have been possible. A million thanks go to all of you.

Unless otherwise noted, the images in this book appear courtesy of the Vintage Kansas City Image Vault, a growing repository of public domain photographs and drawings provided to encourage the propagation and enjoyment of Kansas City history and culture. Images credited MVSC appear courtesy of the Missouri Valley Special Collections of the Kansas City, Missouri Public Library, and with our gratitude.

INTRODUCTION

After the 13 colonies won their freedom from the British, the thousands of miles that lie to the west of the new nation still belonged to other European countries, with France and Spain owning vast expanses of land in the New World. But maintaining empires and fighting wars both at home and across the Atlantic Ocean proved to be expensive back in Old Europe. Napoleon Bonaparte abandoned his quest for a French foothold in the new land and sold his 828,000 square miles of Louisiana Territory to US president Thomas Jefferson in 1803. For the bargain price of less than 3¢ an acre, the area that today is Kansas City became part of the United States of America.

For more than 100 years, French and other European fur trappers and hunters had roamed the area, living amongst and trading with the original Americans who were native to the land. After Louis and Clark's famous expedition to explore the nation's new territory, the military outpost Fort Osage was established. On the banks of the river named for the Missouria tribe of Native Americans, a French fur-trading outpost was built in 1821. The same year, the Santa Fe Trail began providing a trade route to the newly independent country of Mexico. Steamboats began carrying cargo up the Missouri River, and wagon trains from the east brought pioneers heading west to populate the new territory and the land beyond it.

The City of Kansas would be carved out of steep river bluffs to become one of the most exciting and innovative American cities of the 1800s and throughout the turn of the century. Situated in the center of the nation, Kansas City would grow and thrive to become the Heart of America, a crossroads linking east to west, and north to south. The stockyards would see millions of head of livestock coming through on their way to tables across America, giving the city its reputation as a cow town and giving the world a prized cut of meat known as the Kansas City strip. Theater, opera, and art would bring the town culture and, coupled with its central location, make it one of the largest convention centers in the United States.

Railroads, real estate speculation, and banking laid the groundwork for a booming economy. As the frontier outpost evolved into a thriving metropolis, the influences of the pioneers and immigrants who passed through or stayed to call Kansas City home absorbed into the melting pot of a true American community, which sent its own influences back out into the world. At the turn of the 20th century, city leaders determined to make Kansas City "A City Beautiful" developed parks and boulevards that were copied in cities worldwide. Public welfare pioneers worked to alleviate poverty and established systems of social work that would be emulated across America.

From this great community have come many people famous worldwide who were born here, grew up here, or otherwise called Kansas City "home" at some point in their lives. Harry S. Truman ran a haberdashery on Twelfth Street before he entered politics. Walt Disney took courses at the Kansas City Art Institute. Ernest Hemingway was a cub reporter for the *Kansas City Star*. Walter Cronkite was a sports reporter for radio station KCMO. Hollywood legends like William Powell, Jean Harlow, Ginger Rogers, Joan Crawford, Ed Asner, and many others grew up or lived amongst Kansas Citians in their younger years. Kansas City was home to jazz legends, including Charlie Parker and Count Basie, and sports legends too numerous to mention here.

But Kansas City was also home to Jacob Billikopf, whose pioneering work in the field of social welfare would be copied by cities across the country and make him a treasured friend of Albert Einstein. It was home to George C. Hale, a fire chief who not only patented dozens of devices that revolutionized firefighting worldwide but also created a motion-picture thrill ride that would play a role in the early careers of entertainment pioneers like Sam Warner and Walt Disney. It was home to George Kessler, a landscape architect who beautified the city so splendidly that he was called to cities as far away as New York and Singapore to create lasting beauty all over the world.

The story of Kansas City is evolving every day, but in these pages is where it all began, and the story of Kansas City starts millions of years ago.

Some of the oldest and most beautiful buildings in Kansas City were created with material taken from the dozen or so limestone mines that lie beneath the surface of this town. The limestone was laid down 300 million years ago when all the land on the Earth was one great continent called Pangaea; at that time, Kansas City was situated close to what is now the equator.

After this land mass split up, a huge inland sea existed between the Rockies and the Appalachian Mountains, with the water eroding and exposing the older rocks, leaving behind the fossils we find around town, like the Crinoid, the official fossil of the state of Missouri. These were left from plant-like animals that lived 270 million years ago in shallow seas. Brachiopods were clam-looking creatures that attached themselves permanently to the sea floor. Over millions of years, sediment deposits would encase and preserve these prehistoric creatures, and these sediment deposits would be compacted and compressed to form the limestone you find in abundance above and beneath Kansas City.

Three million years ago the tectonic plates of the South and North Americas connected at what is now Central America, causing the first of four ice ages. The Missouri River hooked up to the Kansas River around 150 million years ago, as another ice age ended, resulting in the Missouri River valley. The last ice age to reach Kansas City happened about 200,000 years ago.

One result of an ice age is a drop in sea level. At the end of the last ice age, about 14,000 years ago, the Bering Straights between Alaska and Siberia popped out of the sea, leaving a land bridge between the two. In four migrations, Asian people came to North America via this exposed stretch of land, from Eskimos to the Mayans, and the Native Americans who inhabited the Kansas City region were descendants of these brave individuals.

Nomadic tribes came and went throughout our area for thousands of years, leaving behind ancient relics that were discovered when early city workers blasted through hillsides to create roads and excavated deep foundations while building the town's first skyscrapers.

At the time the Europeans arrived in this region in the early 19th century, the area that would someday become Missouri was inhabited by the Osage and Missouria tribes, with the Kansa tribe living farther west in what would someday be a state named after them.

One

EUROPEANS ARRIVE

By the time Lewis and Clark arrived, Kawsmouth, then the name of the area where the Missouri and Kansas Rivers meet, was already an important area of commerce in both the New World and the Old. In population, humans were few and far between, but furry beavers flourished, with skin prized in Europe for hat making. French and Native American trappers lived in harmony and prospered by capturing these and other creatures and transporting their pelts on the Missouri River in keelboats and other watercraft for sale to the fur traders on the Mississippi River.

In 1821, François Chouteau was hired by the American Fur Company to set up a trading post on the Missouri River near Kawsmouth, creating a settlement with his wife and other French descendants on the Randolph Bluffs in Clay County. In 1826, flooding forced François to move his little community five miles upriver, near where today Troost Avenue would meet the Missouri River. This would be Kansas City's first European settlement.

The Indian Removal Act of 1830 by Congress would bring thousands of Native Americans of many tribes through this area along what was called the Trail of Tears. For some reason, Rev. Isaac McCoy felt that the only way to "save" these natives from the evil influence of the White Man would be to forcibly move them to the most barren part of the country. After helping to bring about the legislation, he brought his family here to survey the new "Indian Territory." As the reverend ministered to the displaced natives, his son John Calvin became an enterprising entrepreneur, and Westport, four miles east of the Missouri River, was born.

John Calvin McCoy knew that if he could tame the craggy river bluffs and build a road to Westport, he could make his town an important outpost on the Santa Fe Trail. So land was acquired, the bluffs cut away, and a city was born. Farmer and ferry operator Gabriel Prudhomme owned 271 acres on the levee. After his death in a brawl, hungry businessmen, including McCoy, would obtain this land. These are the beginnings of Kansas City.

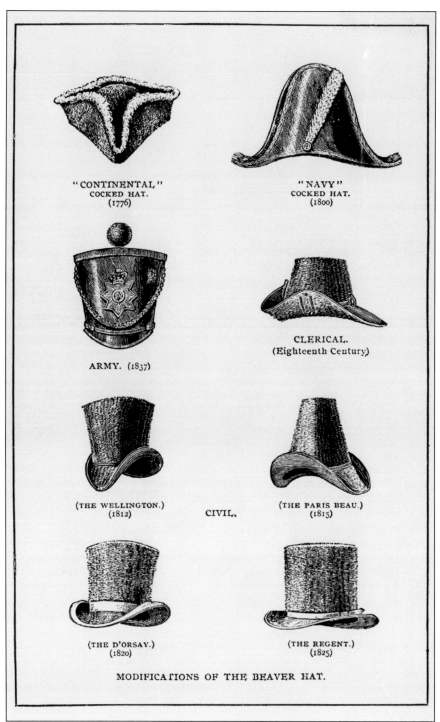

"CONTINENTAL"
COCKED HAT.
(1776)

"NAVY"
COCKED HAT.
(1800)

ARMY. (1837)

CLERICAL.
(Eighteenth Century)

(THE WELLINGTON.)
(1812)

CIVIL.

(THE PARIS BEAU.)
(1815)

(THE D'ORSAY.)
(1820)

(THE REGENT.)
(1825)

MODIFICATIONS OF THE BEAVER HAT.

Prized in Europe, beaver skin was used for the making of felt hats for centuries. Since the 1500s, French hunters and trappers and their descendants lived peacefully in North America amongst the Native Americans, who traded pelts for things like tools and weapons. This would continue until the mid-1800s, when silk became the preferred material for hat making.

10

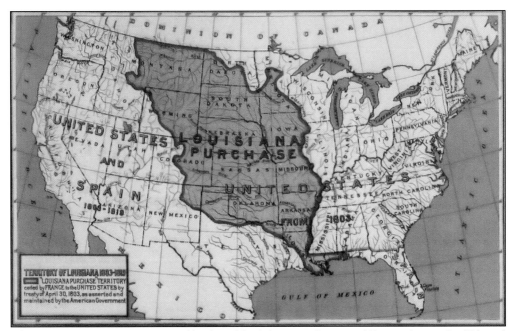

The Louisiana Territory was passed back and forth between Spain and France during the 17th and 18th centuries, but Napoleon Bonaparte wanted the land for a French colony in North America. The rising costs of Napoleon's other conquests, along with an impending war with Great Britain, led the emperor to sell the territory outright to the new United States, in exchange for $15 million in cash and debt cancellations.

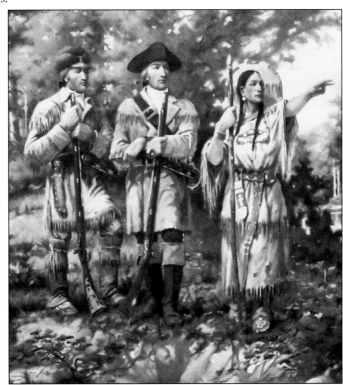

Meriwether Lewis and William Clark of the US Army were commissioned by Pres. Thomas Jefferson to lead the Corps of Discovery expedition between 1804 and 1806 to survey the new territory. They camped along the Kansas River near Wyandotte in 1804 and, on their return trip in 1806, camped on the Missouri River bluffs at what is now Quality Hill, calling the spot, "a commanding situation for a fort." (Samuel Edgar Paxton.)

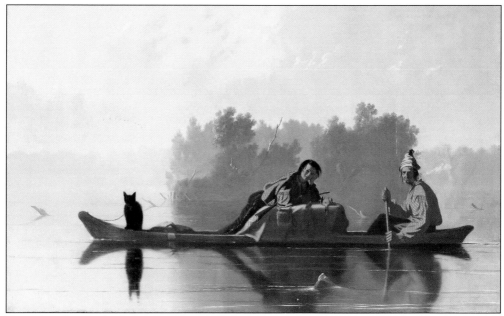

For perhaps hundreds of years, French and Native Americans worked together and often intermarried as they hunted the wilderness for furs, bringing them in bundles down the Missouri River on canoes, keelboats, and other types of early watercraft. Kansas City artist George Caleb Bingham captured a moment in the life of a typical fur trader in his painting "Fur Traders Descending the Missouri in 1845."

1833 brought to Kawsmouth a French priest named Benedict Roux, and the Chouteaus built the first church in what would later become the City of Kansas. In his log church, named St. Francis Regis (called by most "Chouteaus' Church"), Father Roux preached to, baptized, and chastised persons of all races and walks of life, often butting heads with the wife of François Chouteau, Bérénice, due to his disapproval of the dances she loved to host.

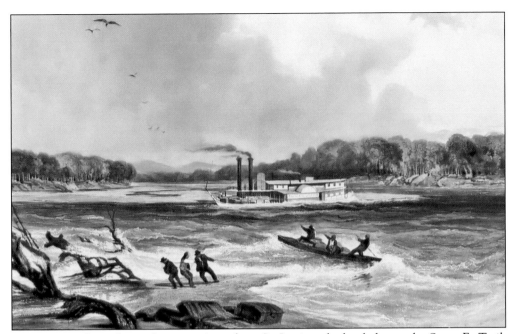

In 1831, steamboats began bringing cargo from St. Louis to be hauled over the Santa Fe Trail. Their stopping point was the Wayne City Landing, also known as Independence Landing, six miles east of what would become Kansas City. It was the farthest point west that steamboats could travel on the Missouri River. Established in 1827, Independence was a quickly growing frontier town due to the Santa Fe trade and a large migration of Mormons.

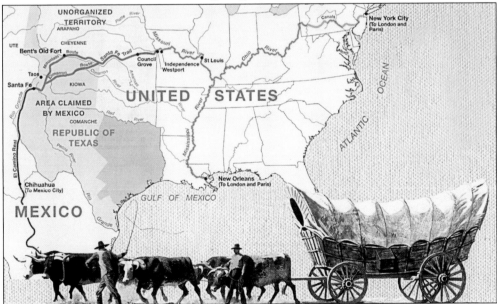

When Mexico won its independence from Spain in 1821, the Santa Fe Trail was created as a highway for merchants to take advantage of new trade opportunities and for military transportation. It would later become an invasion route during the Mexican-American War; afterwards, it was the trail that led eastern settlers to the new southwest region of the United States. (Robert McGinnis for the National Park Service.)

On December 28, 1831, Rev. Isaac McCoy brought his family and built a large log house near what would become the town of Westport. His 1829 book, *Remarks on the Practicability of Indian Reform*, was part of the impetus that made the relocation of Native Americans the next year an act of law. He spent his years surveying the Indian Territory for the government, while ministering to the territory's new, reluctant residents.

Fellow missionary/surveyor Johnstone Lykins worked with Reverend McCoy to minister to the newly arrived Shawnees in an attempt to convert them to the Christian faith through the Shawnee Mission. In 1831, their Baptist church counted a dozen Native Americans amongst its members. With printer and fellow preacher Jona Meeker, they produced elementary schoolbooks to educate people in the Shawnee, Chippewa, and Delaware tribes throughout the Indian Territory.

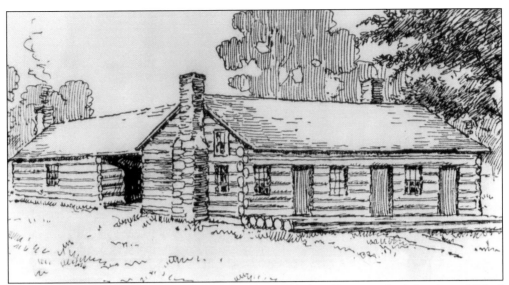

When the McCoys arrived, Daniel Yoacham and his family from Tennessee had already established Westport's first tavern, which was located at Westport Avenue and Mill Street. The tavern served as a gathering place for trappers, Native Americans, traders, hunters, soldiers, and, unbeknownst to Daniel Yoacham, bandits on their way to rob traders on the Santa Fe Trail.

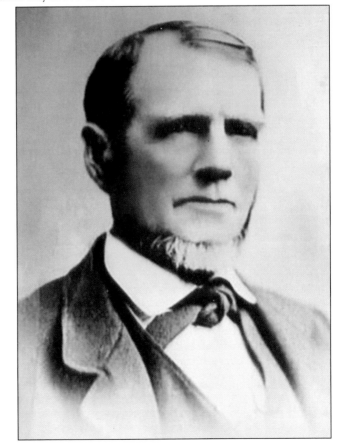

In 1833, the enterprising son of Rev. Isaac McCoy, John Calvin McCoy, built a two-story log building at Westport Road and Pennsylvania Avenue, where he and business partners J.P. Hickman and J.H. Flourney traded with Native Americans, mountain men, and westward-bound wagon trains. In 1834, McCoy bought the land surrounding his trading post from Dr. Johnston Lykins and established a town called Westport.

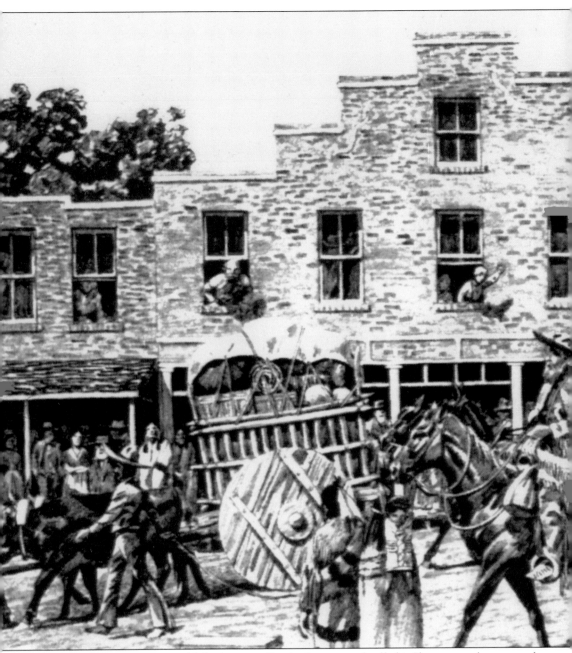

In 1832, the government established a post office in the area and called it Shawnee, to be renamed West Port two years later. John Calvin McCoy bought the land surrounding his store and platted it off as a township called Westport, which soon became a stopping place for Santa Fe traders awaiting the arrival of goods in Independence. Merchants, mechanics, and tradesmen began setting up shop to cater to those passing through and to the Native Americans, many of whom

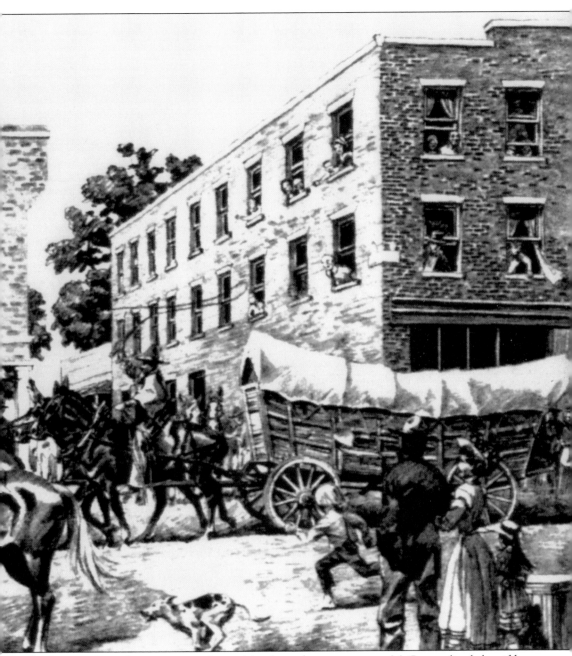

had money from fur trapping and annuities from the government. McCoy realized that if he could move goods from the rocky bluff along the river four miles north, 12 miles could be saved for traders on the Santa Fe Trail, who were used to traveling to Independence before heading west. (Kelly's Westport Inn.)

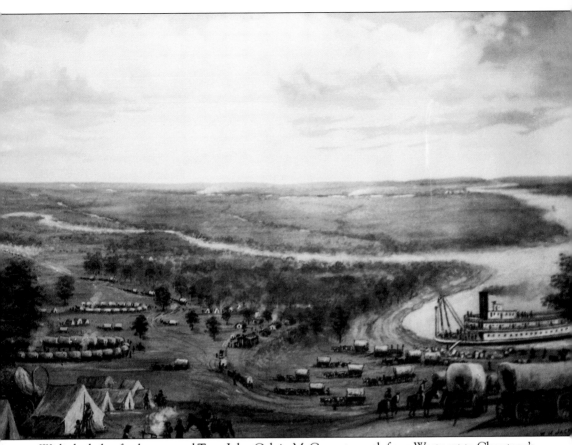

With the help of a slave named Tom, John Calvin McCoy cut a path from Westport to Chouteau's landing. Then, he discovered a natural rock ledge along the Missouri about a mile upriver that he thought would be perfect for unloading goods for Westport. In the spring of 1834, the steamboat *John Hancock* dropped off the first shipment that would be unloaded at Westport Landing. Before long, a settlement sprung up along the riverbank, and Westport and the Westport Landing began to thrive. In 1837, the township McCoy platted as Westport was incorporated as a city, and steamboats were coming the extra miles up the Missouri River as Westport began to overtake Independence as the outpost for Santa Fe traders and immigrants heading west.

Two

TOWN OF KANSAS

In 1827, James Hyatt McGee, along with his wife and 12 children, brought the first slaves to western Missouri. The next year, he purchased 320 acres near Chouteau's warehouse and, over the next 10 years, would accumulate over 1,000 acres of land in Jackson County. Like John Calvin McCoy, he had his eye on the land around the natural rock landing that was becoming popular as Westport Landing. The property belonged to the estate of Gabriel Prudhomme, a French Canadian who had purchased 271 acres of riverfront land for $321 in 1830 with the intention of farming and running a ferry across the river. Prudhomme's plans would not be realized, as he was killed in a barroom brawl in 1831.

James Hyatt McGee was made a trustee of the Prudhomme estate by Jackson County in 1838 after Prudhomme's eldest daughter sought legal help to acquire her portion of her father's property. Ordered by the court to auction off the land, McGee advertised the auction in out-of-town papers. Quickly and quietly, on June 7, 1938, McGee played the role of auctioneer with only his friend Abraham Fonda (a stranger to the town) and a few onlookers present. Surprised at the low starting bid, the onlookers, who had not intended to bid, stepped aside to discuss the possibility of throwing their lot in on the property. While they were discussing the matter, McGee declared the 271 acres "Sold!" to his friend Fonda for the low price of $1,800. Outrage ensued, and the county court set aside the sale, ordering another auction, this time with the county sheriff acting as auctioneer.

On November 14, 1838, the second auction was held. This time John Calvin McCoy was ready. With 13 other investors led by St. Louis fur trader William Sublette, McCoy and the newly formed Town of Kansas Company secured the Prudhomme property for $4,220. Abraham Fonda, the original bidder, was one of the investors. The other 13 declined his suggestion of naming the new town "Port Fonda." The Town of Kansas was platted in 1839.

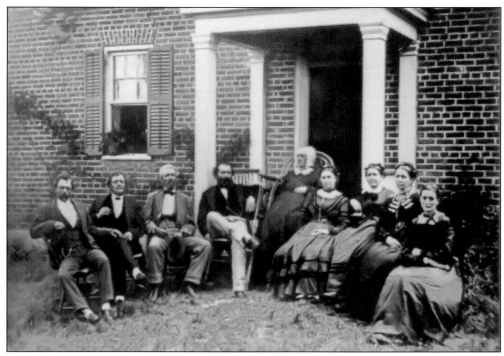

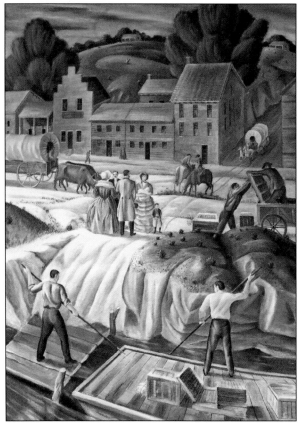

James H. McGee did not get the Prudhomme land, but he still had his own land, a sawmill, distillery, flour mill, and a lucrative government contract providing flour to the Native Americans. When he died unexpectedly in 1840, he left behind a prosperous family, shown here. His son Fry was a Town of Kansas Company investor, and son Elijah would someday be mayor. The McGee legacy lives on in Kansas City even today.

After the Town of Kansas was platted in 1839, legal disputes arose amongst the investors and with the Prudhomme family, preventing the town from officially becoming chartered by Jackson County until 1850. It would not be recognized by the state of Missouri until 1853. Throughout the 1840s, though, the Town of Kansas grew rapidly in population and prospered as an up-and-coming frontier river town.

William Gillis arrived with the relocated Delaware tribe in 1831 and became one of the original investors in the Town of Kansas Company. Having made a fortune trading with Native Americans, the slave owner built an elegant plantation that encompassed most of today's west side. With Dr. Benoist Troost, he built the Gillis House and would later finance Kansas City's first newspaper, the *Enterprise*, forerunner to the *Kansas City Journal*.

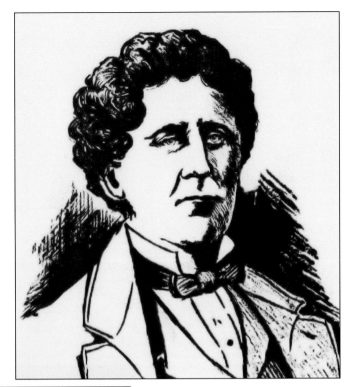

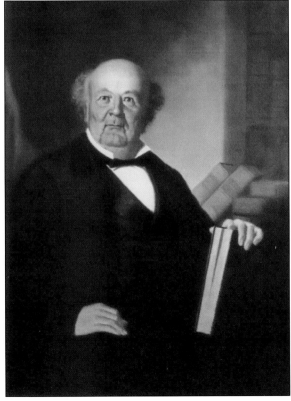

Born in Holland, Dr. Benoist Troost was the area's first practicing physician. He came to the Town of Kansas in the 1840s and bought five of the lots sold by the Town of Kansas Company. The widower married Mary Kennerly, the also-widowed niece of his business partner William Gillis. When the town was officially incorporated in 1853, Troost became one of the governing trustees. (George Caleb Bingham.)

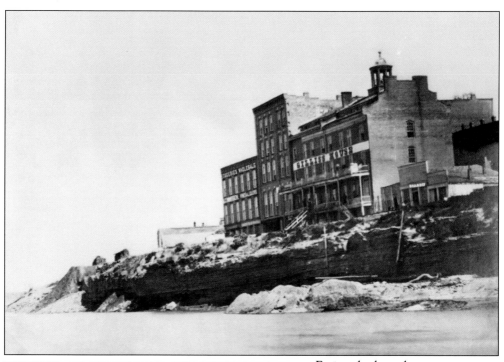

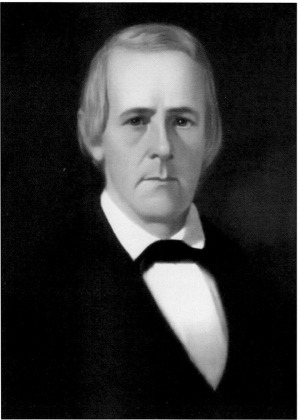

Facing the levee between Delaware and Wyandotte Streets was the Gillis House Hotel, built to capitalize on the Gold Rush fever that was bringing fortune-seekers through Kansas City by the thousands. It was also packed with river men, pioneers passing through, Santa Fe traders, and new Kansas City residents who had not found any place to call home yet, rich and poor alike.

William Miles Chick, a colonel in the War of 1812, came to Westport in 1837 and operated a general store. One of the original investors in the Town of Kansas Company, he would close his Westport store and build a fur warehouse near the river. He also built the first large home in the new Town of Kansas. Chick was the town's first postmaster. He passed away in 1847. (George Caleb Bingham.)

Rev. Nathan Scarritt came to Westport in 1848 to teach at the Shawnee Methodist Mission's school, also creating the area's first taxpayer-funded school in the church's basement. He married Martha Chick and roamed the region, preaching and helping establish churches, until settling on the bluffs overlooking the Missouri River. Investments made Scarritt a wealthy man, and his Scarritt Point became and still is one of the most beautiful areas in Kansas City.

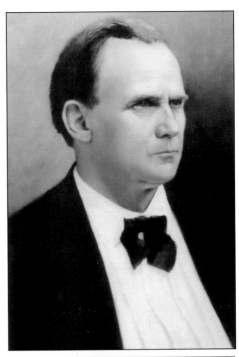

The Westport Main School started in 1854 in the basement of the Westport Methodist Church. Reverend Scarritt served as both church pastor and schoolteacher. In 1856, it became the first taxpayer-supported school in the area, when $1,000 in taxes was collected to purchase the basement rooms of the church for the school's exclusive use. The building pictured was constructed in 1868 at a cost of $12,000.

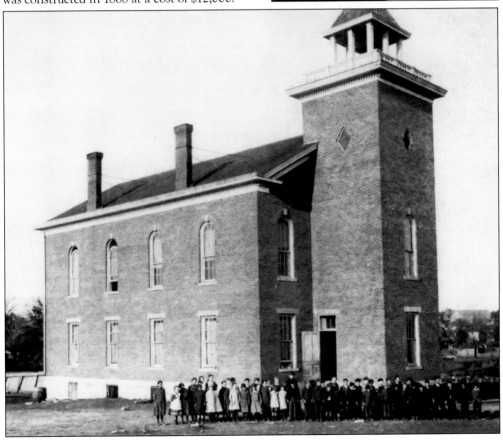

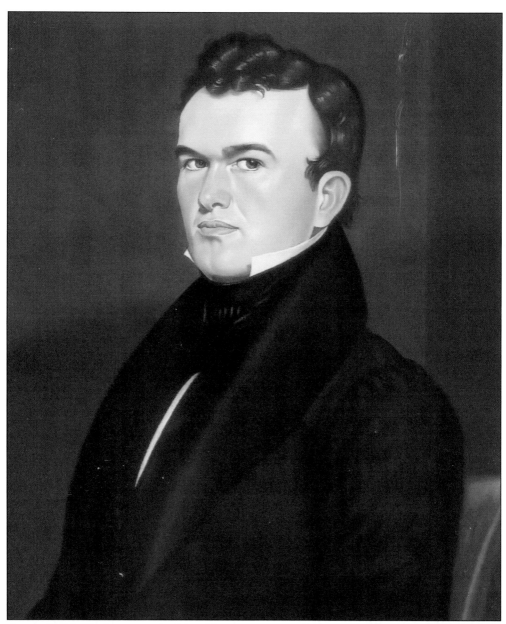

George Caleb Bingham, seen in this self portrait, is one of the most celebrated American artists of the 19th century. Born in Augusta County, Virginia, in 1811, he grew up in Missouri and was a self-taught artist who traveled around Missouri in his early adulthood earning his living primarily as a portrait painter. He was a state legislator and treasurer and fought in Van Horn's Regiment during the Civil War. Throughout his career, he created works of art that celebrated the scenery and folklore of America, as well as paintings that reflected his interest in politics. In 1874, he served as the first president of the Kansas City Board of Police Commissioners. The next year, Missouri governor Hardin bestowed upon Bingham the title of adjutant-general of the state of Missouri. He was the first professor of art at the University of Missouri in Columbia shortly before his death in 1879. Though his paintings were regionally famous during his lifetime, it would not be until the 1930s that his artwork would achieve international acclaim.

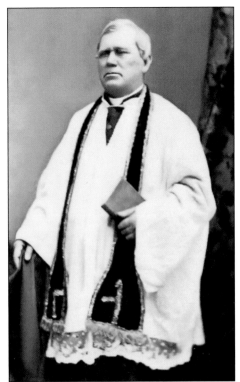

Fr. Bernard Donnelly was an engineer who came to America from Kilnacreva, Ireland, in the 1830s and entered a Catholic seminary in St. Louis. He took over Father Roux's congregation in the 1850s, bringing 300 laborers from Ireland to work in his brickyard and stone quarry that provided building materials not only for his own church but also for many of the structures being built in the growing town. Shown below is the Redemptorist Church at Linwood Boulevard and Broadway.

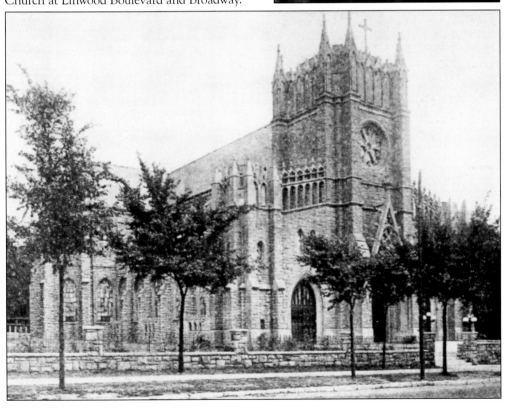

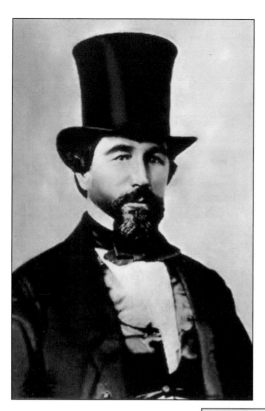

Alexander Majors played an important role in the growth of the American West. In his overland freight business, he won government contracts to supply military forts along the Santa Fe Trail. He was among the first to unload freight at the Westport Landing, helping grow the place that would soon become Kansas City. With his business partners, he founded the Pony Express and the Overland Stage Company. For several years, he prospered as a merchant to wagon trains heading west and owned a meatpacking plant in Westport. (Wornall/Majors House Museums.)

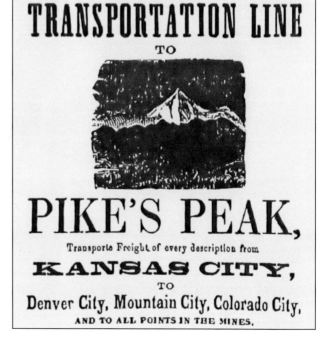

This is an 1858 advertisement for Alexander Majors's passenger and freight service to Colorado, a popular destination for adventurers and treasure hunters after gold was discovered at Pike's Peak.

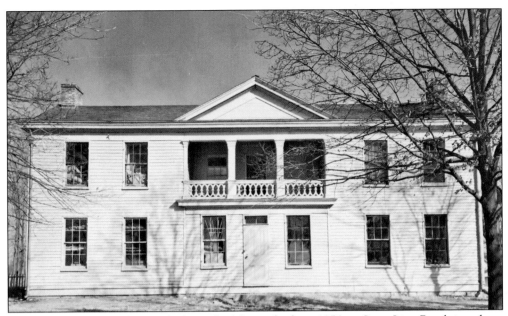

The 3,500-square-foot home of Alexander Majors, built in 1856 on State Line Road, is today a museum sitting on the five-acre Russell Majors Waddell Park, named after his shipping company that at one time owned 3,400 wagons and 40,000 oxen, and employed 4,000 men. The home is listed in the National Register of Historic Places.

Over time, the advent of the telegraph and railroads diminished his business prospects, so Alexander Majors sold all his interests and moved to Colorado. There, almost penniless, he was reunited with a former Pony Express rider, Wild Bill Cody, who took Majors on as part of his Wild West show. Pictured here is Alexander Majors, center, with Wild Bill Cody on his right. The other men are unidentified.

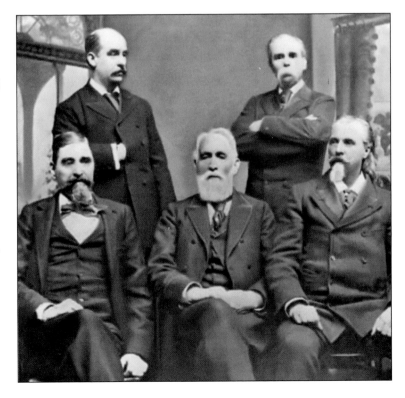

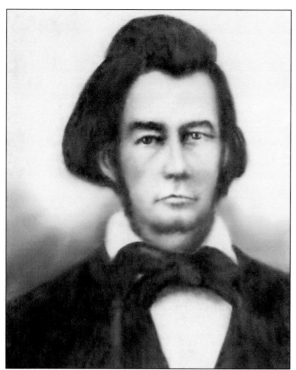

Thomas Jefferson Goforth brought his family to Missouri in 1837 and worked as a sign painter in Independence before moving to Westport in 1950 to practice law. Nicknamed "the Squire," he was a popular man who strolled around wearing a top hat and carrying a walking stick.

Goforth served as the town's justice of the peace for decades and became the first mayor of Westport after the town's official incorporation in 1857. This was an office he would be elected to six times, serving different one-year terms, between 1857 and 1879. Pictured is the building holding Westport's town hall and jail, constructed in 1860.

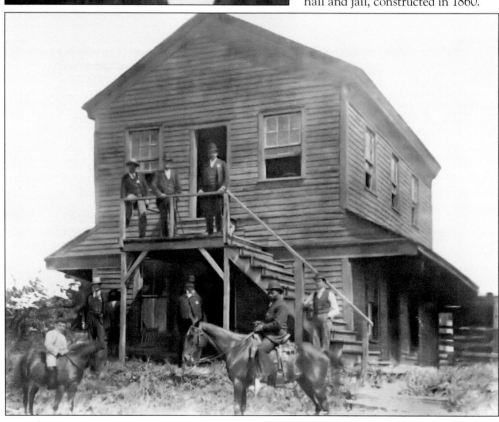

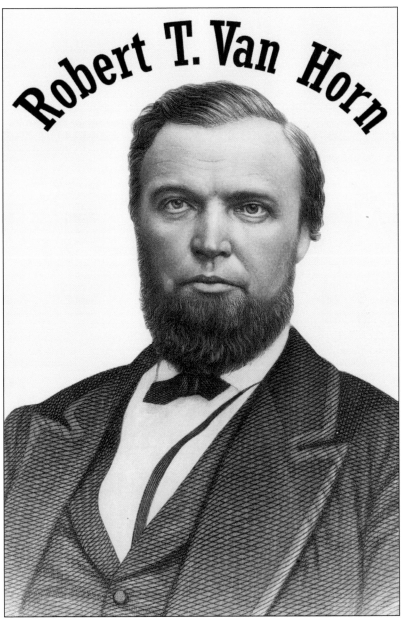

Robert T. Van Horn

In the history of Kansas City, there are few if any statesmen whose careers and accomplishments did more to build Kansas City into one of America's most important communities in the 19th century and beyond than Robert Van Horn. As mayor and soldier, he would save Kansas City from the Confederacy during the Civil War. As US congressman, he would bring the first bridge to span the Missouri River to the town he represented. Besides serving in uniform and in Congress, he served the city as postmaster, alderman, and state legislator. From the time he arrived in town in 1955, his ambition was to build Kansas City into one of the most important cities in America. His first step was to purchase the town's weekly newspaper, the *Enterprise*; as an editor, his life's work of realizing Kansas City's potential was begun. Where others saw muddy roads and impossible terrain, Van Horn saw the future and used his optimism and printing press to convince the world of the greatness of Kansas City.

William Gillis, Dr. Benoist Troost, and other city leaders started the weekly *Kansas City Enterprise* in 1854. Van Horn bought the paper for $250 one year later, retaining David Abeel as the publisher. Operated above a tavern at Main Street near the levee, it would soon be called the *Western Journal of Commerce* and, in 1958, would become the *Kansas City Daily Western Journal of Commerce*, Kansas City's first daily newspaper.

Robert Van Horn published his paper and used his printing press to serve the needs of the growing business community. The *Journal* would create a sensation when it published reports of gold being discovered in "Western Kansas" (there was no Colorado at the time). Fortune-seekers came by the thousands, but rival outfitting towns, like St. Joseph and Leavenworth, were displeased at the attention Van Horn was bringing to Kansas City.

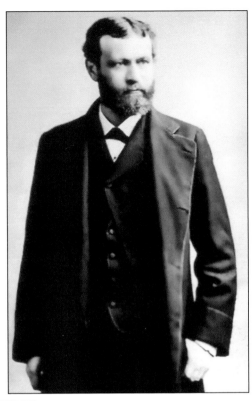

Born in Hanover, Germany, in 1835, Louis Hammerslough came to America at the age of 19. By 1858, he and his brothers were successful dry goods merchants back east. Louis saw promise and opportunity in Kansas City and brought a branch of their men's clothing store and outfitter to Kansas City, located at Fifth and Main Streets. Before, during, and after the Civil War, Hammerslough Bros. sold thousands of dollars worth of merchandise to locals and travelers heading out on the Santa Fe Trail. Louis Hammerslough was instrumental in organizing the Kansas City Board of Trade and was a charter member and first president of the B'nai Jehudah Congregation, which formed in 1870. Hammerslough was also the publisher of Kansas City's daily German newspaper, the *Morning Post*.

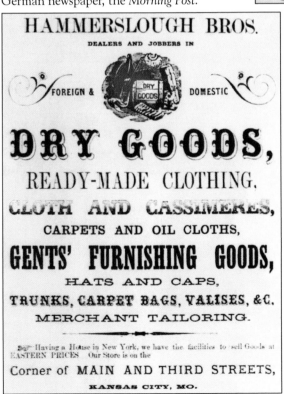

HAMMERSLOUGH BROS.

DEALERS AND JOBBERS IN

FOREIGN & DOMESTIC

DRY GOODS,

READY-MADE CLOTHING,

CLOTH AND CASSIMERES,

CARPETS AND OIL CLOTHS,

GENTS' FURNISHING GOODS,

HATS AND CAPS,

TRUNKS, CARPET BAGS, VALISES, &C,

MERCHANT TAILORING.

Having a House in New York, we have the facilities to sell Goods at EASTERN PRICES Our Store is on the

Corner of MAIN AND THIRD STREETS,

KANSAS CITY, MO.

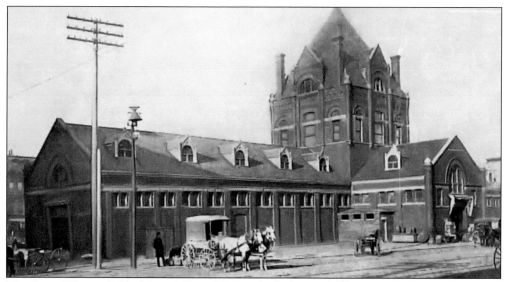

The City of Kansas, led by Mayor Milton J. Payne, built this city hall in 1857. It was combined with the City Market near the levee. Before this time, the city's administrative offices were combined with the police headquarters, at Fourth and Main Streets.

Kersey Coates came to Kansas City from Pennsylvania in 1854. The Quaker had taught school and practiced law before he came out west to speculate in real estate and get involved in the antislavery Free State movement. He married a fellow Pennsylvanian and bought some land on the bluffs of the Missouri River from Bérénice Chouteau, the widow of François Chouteau, who had passed away in 1838.

Three

THE CIVIL WAR

The violence of Bleeding Kansas, the Missouri-Kansas border war between abolitionists and pro-slavery "Border Ruffians," was driving settlers in Jackson County away by the thousands in the years leading up to the Civil War. Kansas City was a city divided.

On April 30, 1861, a Confederate flag was raised in Kansas City at Second and Main Streets. Mayor Robert Van Horn, an avowed Unionist who had recently won a close election in a town of divided loyalties, had asked for and was given the rank of major in the Enlisted Missouri Militia. Van Horn sent to Fort Leavenworth for reinforcements. Capt. W.E. Prince brought two companies of infantry and three of cavalry to Kansas City, which sent the Secessionists scampering east toward Independence. A skirmish with Prince's men at Rock Creek left three Secessionists dead and two wounded, and they headed for Blue Springs while Prince's men returned to Kansas City.

Van Horn's battalion of the US Reserve Corps was mustered into service on June 24, 1861, eventually headquartered on the southwest corner of Tenth and Central Streets, with the grounds of the unfinished foundation of the Coates House Hotel serving as the cavalry stables. Company A was called the German Company, Company B the Irish Company, and Company C was the American Company. Volunteer George Caleb Bingham was given the rank of captain; Kersey Coates was given the rank of colonel, and Theodore Case became second lieutenant. Captain Prince's men went back to Leavenworth.

Van Horn's regiment engaged in battles in Cass County and was called for reinforcement in the Battle of Lexington, where Van Horn was wounded and his regiment taken prisoner. Following the siege of Lexington and surrender of the Union forces, Van Horn's battalion was reorganized with Col. Everett Peabody's Independent Battalion of St. Joseph as the 25th Missouri Volunteer Infantry, sent south to fight other Union battles, all the way to Vicksburg.

Residents of Jackson County fled by the thousands, as William Quantrell's "Bushwackers" engaged in the famous Border War, and trade in Kansas City and on the Santa Fe Trail came to a near standstill. Upton Hayes joined the Missouri State Guard militia of Confederate forces, fighting in the First Battle of Independence and the Battle of Lone Jack. He was killed by Union forces on September 15, 1862, taking a bullet to the head.

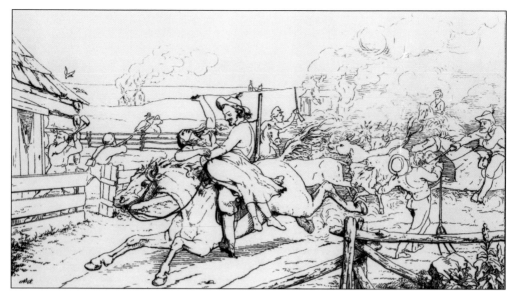

As Kansas prepared for statehood, the battle over whether it would be a free state or a slave state was bloody and violent on both sides of the state line in the run-up to the Civil War. "Jayhawkers" were a militia of Kansas Free-Staters. On the Missouri side of the line were the "Border Ruffians," slavery supporters who took up arms and crossed into Kansas to "force" Free-Stater residents to change their minds. Besides their political agendas, both guerrilla groups were well known to use their causes for purposes of looting and pillage before and during the war. Charles Jennison's Jayhawkers are pictured above attacking a Kansas homestead in an 1864 drawing by Adalbert John Volck. Below are William Quantrell (left) and Bloody Bill Anderson (right), notorious Bushwhackers responsible for the 1863 massacre of Lawrence, Kansas.

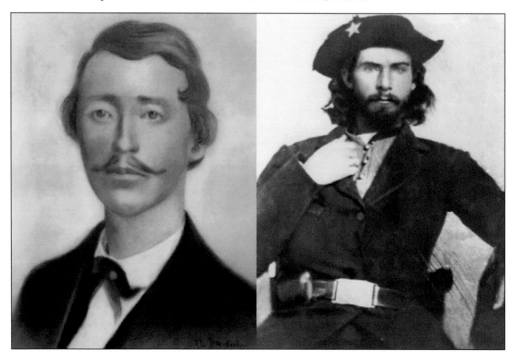

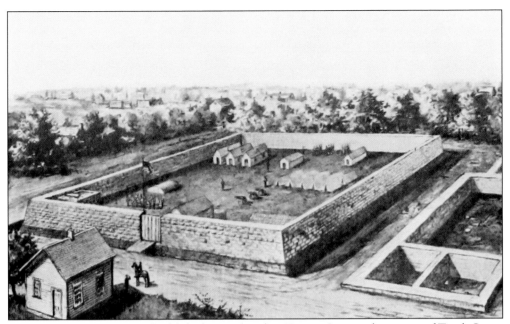

Kersey Coates was going to build the biggest hotel in Kansas City on the corner of Tenth Street and Broadway and he had the foundation dug out and laid when the Civil War began. Kersey's hotel foundation would be boarded over and serve as a cavalry stable for Fort Union, headquartered on the southeast corner of Tenth and Central, a block away.

Theodore Case came to Kansas City in 1857 with college degrees in science and medicine. In 1860, he became an alderman and, when the Civil War began, he enlisted in Van Horn's Regiment. As a second lieutenant he was the quartermaster in charge of the soldiers' food, equipment, and clothing. After the war, he would earn the rank of colonel and be appointed quartermaster general for the state of Missouri.

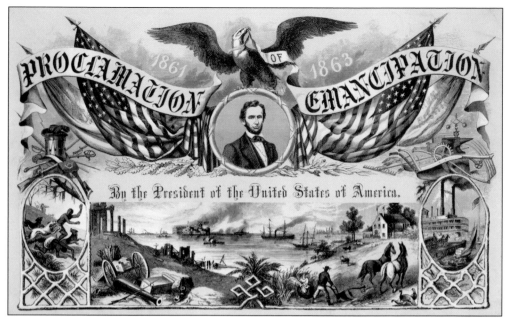

The Emancipation Proclamation went into effect on January 1, 1863, and slavery was officially outlawed in Kansas City. A year later, the city celebrated the anniversary while the band of the 11th Kansas played music, but in Clay County, there was nothing to celebrate as most of Missouri did not recognize Emancipation. Slaves from the Northland regularly tried to make their way across the river toward freedom, often with gun battles, but bounty hunters living in Kansas City made the town unsafe, so most headed toward "John Brown's land" in Kansas. In 1862, Kansas abolitionist and US senator James Lane formed a regiment of African American soldiers called the First Kansas Colored Infantry Regiment. Freed and escaped slaves battled Confederate guerrillas in Missouri and Kansas. The next year, African Americans were formally allowed to join the Federal army.

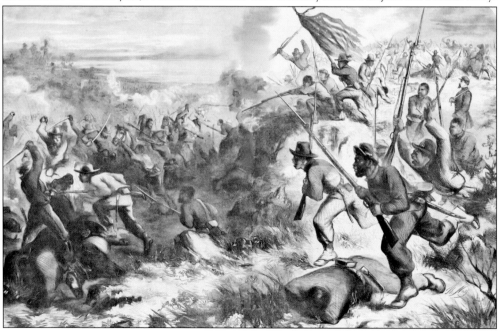

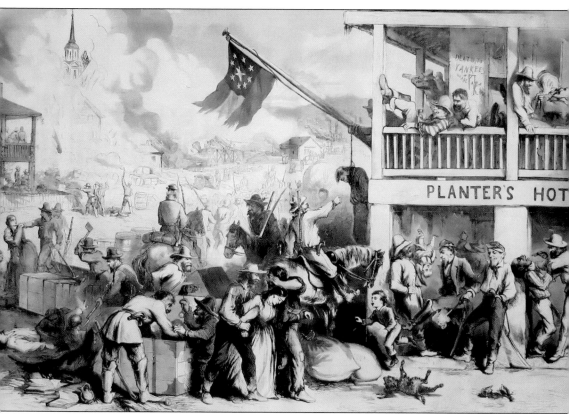

Bushwhackers and other Confederate guerrillas were wreaking havoc in rural areas throughout the border states. A strong military presence in Kansas City prevented them from attacking in the town, but their women would come here for groceries and supplies and allegedly to spy on Union forces. In July 1863, Union soldiers started rounding up women thought to be aiding the guerrillas. At first, they were held at the Union Hotel at Sixth and Main Streets but were eventually moved to the rooms above the Longhorn Tavern in McGee's Addition. This building was owned by the late father-in-law of George Caleb Bingham, who had used the rooms for painting before moving to Jefferson City to serve as state treasurer. The building collapsed on August 13, 1863, killing four of the women prisoners (another would die later from the injuries). Among the dead was Josephine Anderson, sister of William Anderson, who would soon earn the nickname "Bloody Bill" for his actions in retaliation for his sister's death.

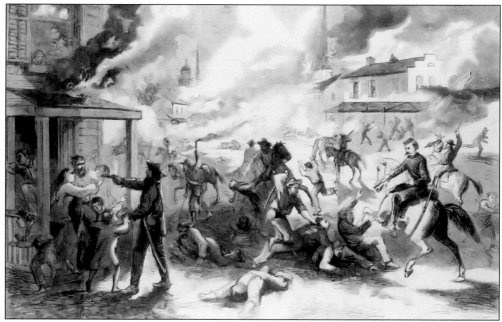

A week and a day after the collapse of the building holding Bloody Bill's sister, between 300 to 400 armed men on horses, led by William Quantrell and "Bloody Bill" Anderson, rode into Lawrence, Kansas, in the predawn hours to carry out a well-planned attack. Over the next four hours, they would loot and pillage the banks and stores of the town, killing almost 200 men and boys, nearly the entire male population of the town, while setting the town on fire. A quarter of the buildings in Lawrence were burned to the ground. The raiders rode out of town and scattered, with the exception of one lone rebel who was captured and lynched. These illustrations were published in *Harper's Weekly* on September 25, 1863.

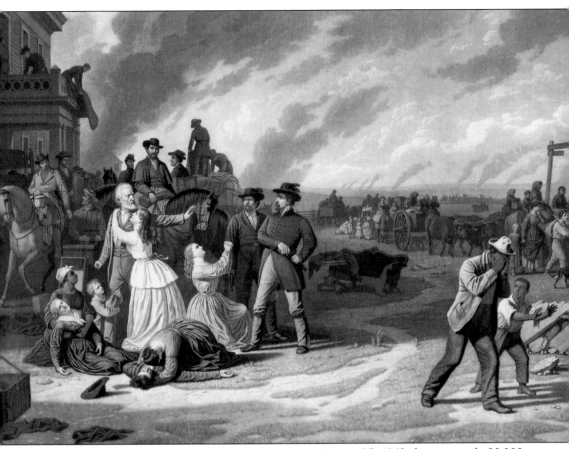

Union general Thomas Ewing issued Order No. 11 on August 25, 1863, forcing nearly 20,000 residents in four western Missouri counties from their homes following Quantrell's raid on Lawrence. Meant to prevent residents from providing material assistance to Bushwhackers, the order had the opposite affect, giving the rebels plenty of shelter and supplies, and turning sympathies away from the Union. John Henderson Miller, a child in Kansas City during the war, later wrote, "The sight of fleeing people was sad in the extreme. Down Main Street passed a long procession of wagons, buggies, and carriages. The vehicles were filled with frightened people, and were packed to overflowing with such household and personal effects as they could gather to take with them." Appealing personally to Ewing to rescind the order, George Caleb Bingham vowed, "If you persist in executing that order, I will make you infamous with pen and brush as far as I am able." After creating the above painting in 1868, Bingham had the painting reproduced and distributed in hopes of ruining Ewing's political career.

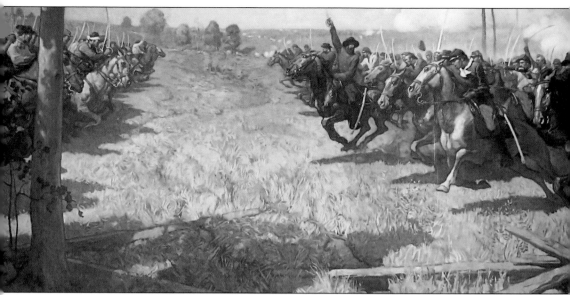

In the fall of 1864, Confederate general Sterling Price started heading north through Missouri, with an eye toward conquering Leavenworth. Kansas City was taking every precaution. Robert Van Horn, mayor and commandant of the military post, mustered a 60-day regiment of resident volunteers and, in his newspaper, warned the city daily to be ready to defend their homes against the coming invasion and the Bushwhackers terrorizing cities in Clay County and around Missouri. Maj. Gen. James Blunt's 2nd Kansas Volunteers fought Price's army at Lexington but were pushed back as far as the Little Blue River, five miles east of Independence. On October 21, fighting alongside Col. Thomas Moonlight's 2nd Brigade, the greatly outnumbered Union forces failed to stop Confederate advance, and the Second Battle of Independence was fought on October 21–22. At the Battle of Westport, joined in Independence by 10,000 Union cavalry from Maj. Gen. Alfred Pleasonton's force, the Union forces retreated to Brush Creek. Blunt had three brigades waiting for the Confederate troops, with another on the way. On the morning of the 23rd, Blunt's troops advanced on the Confederates but were pushed back across the creek. Joined by the 9th Wisconsin Battery, the fight raged on toward Westport, where Price found his men being attacked from the other side by Gen. Alfred Pleasonton's cavalry. With ammunition and supplies running short, Price's men broke and fled to the southwest.

Four

PEACE AND PROGRESS

With peace and order restored, the City of Kansas turned its eyes again on building the greatest city in the west. Progress and growth were resumed immediately. Colonel Van Horn was sent to serve the first of his three terms in the US Congress. The population of Kansas City exploded; in 1860, there were 4,000 residents living in the river town. By 1870, that number would rise to 32,000. The long-awaited train from St. Louis finally arrived, bringing eager settlers to a muddy, hilly place touted in advertisements back east as the land of opportunity. Many, especially the wives who had made the journey, were dismayed upon arriving. Children, like Mary L. Allen, though, felt the sense of adventure that would make many stalwart arrivals ready for the challenge of taming the west in the town by the river. In her 1950 recollections, she wrote:

> The roughness and wildness of this crude border town were to us unspeakably fascinating. The high hills, the deep ravines, the great canyons called streets that had been cut through the bluffs from the river, some of them forty or fifty feet deep; the river itself, with steamboats coming and going all the time . . . the Mexicans and the Indians in feathers . . . the new kinds of food that we tried, such as venison and bear steaks and buffalo meat and wild turkey . . . even the fact of having fireworks at Christmas time instead of the Fourth of July—all these things made up an ensemble that to us was intensely novel and entertaining. We realized no hardships, no deprivations, either at home or abroad. If anyone had told us what we knew afterwards, that our mother was not so happy as we, that she, like most of her sister newcomers, had times of homesickness and of longing for the comforts and associations left behind, we should have been too astonished for words. That anyone should not love to live in this delightful spot would have seemed to us too preposterous for belief.

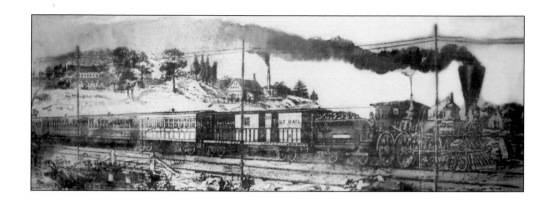

Delayed by the Civil War, the first train to Kansas City from St. Louis arrived on September 21, 1865. The *Kansas City Daily Journal* did not usually run illustrations with its stories, but on this occasion the above image of the Missouri Pacific train was featured, and the *Journal* wrote: "The 'long roll' of their rumbling wheels, heard for the first time in the history of our city announces the arrival of the 'advance guard' of the grand army of enterprise, commerce, industry, and progress, hereafter to assemble at this time the railroad center of the Missouri Valley." Below is artist Frank Nuderscher's depiction of the occasion painted for a mural for the Missouri Pacific Museum. (Missouri State Archives.)

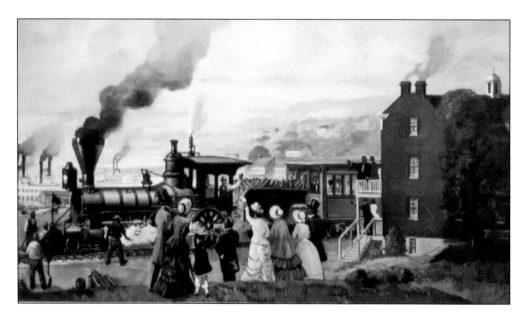

After the war, construction was resumed on the Coates House Hotel at Tenth and Broadway. Designed by Henry Van Brunt and Frank Maynard Howe, the luxurious hotel was host to presidents and celebrities, as well as home to many prominent locals. In 1870, the Coates Opera House opened across the street from the hotel. The city's first real theater would host the world's top performers. Theatergoers often had to work their way through muddy roads to get to the venue. (Wornall/Majors House Museums.)

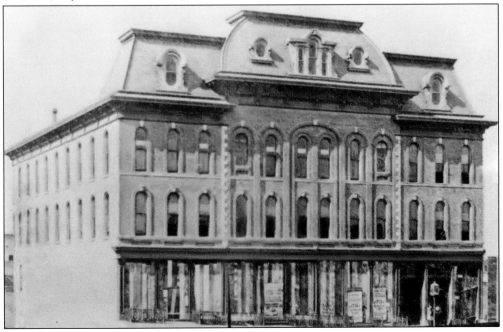

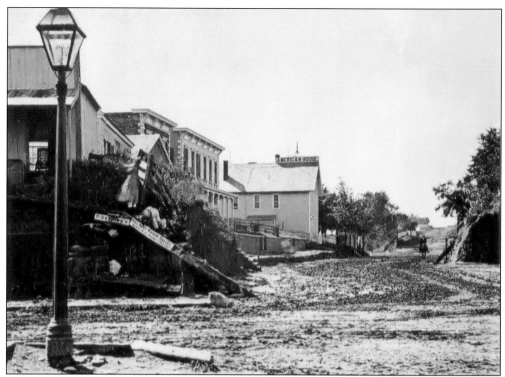

Lighting up streets was found to increase commerce and reduce crime outdoors at night in Europe and in cities back east. The KC Gas, Light and Coke Co. was organized in 1865, and by 1867, under Mayor Edward Herrick Allen, gas streetlamps were in place throughout Kansas City.

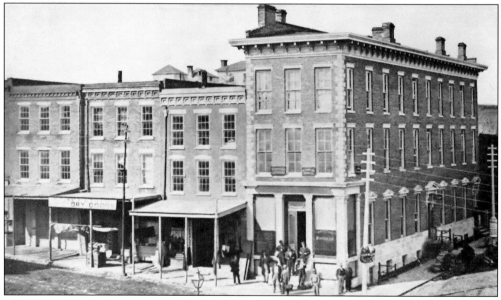

The area around Main and Second Streets was considered the business center of Kansas City in 1867. This photograph shows a group of men standing in front of Watkin's bank, one of the earliest banks in town. In 1860, the trade of the city was just over $10 million. By 1867, that number would more than triple to $33,006,827.

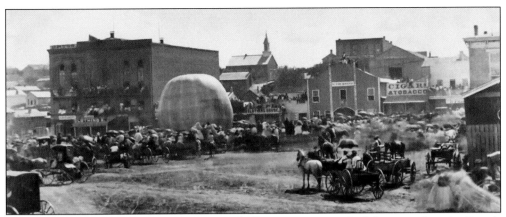

This photograph shows the city's first hot-air balloon ascension, which happened on the Fourth of July in 1868, in the town square. Balloon ascensions would become a popular occurrence over the coming decades, with no large celebration being complete without one. Competitive balloon racing would become a popular sport in the future parks of the town.

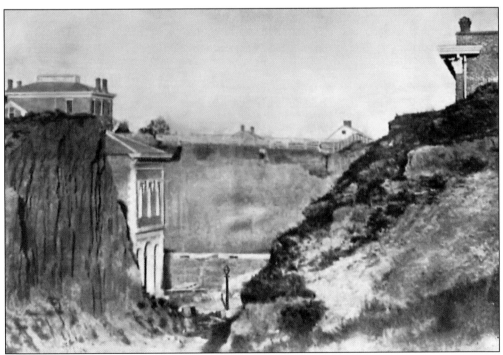

This is Second and Main Streets in 1869. Kansas City would spend decades flattening the cliffs and hills using pick axes, sledgehammers, and later, dynamite. Before the grading, getting anywhere around town from the levee meant making one's way through muddy ravines and climbing hills or dozens of steps to get to buildings that were perilously perched on the edges of steep ledges.

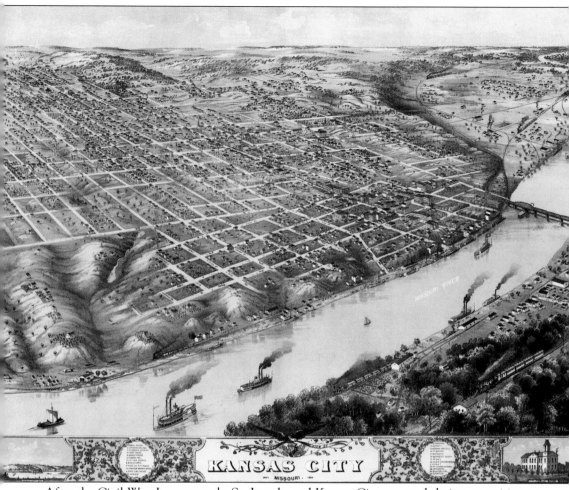

After the Civil War, Leavenworth, St. Joseph, and Kansas City renewed their competition to become the commercial epicenter of the Midwest with a vengeance. Knowing that being the first town with a bridge across the Missouri River would be the key to this, Robert Van Horn, Kersey Coates, and Charles E. Kearney joined forces to make that happen.

Charles E. Kearney (right) came to America from Ireland as a young man and joined the Texas Rangers. After the war with Mexico, he came to Westport to capitalize on the Santa Fe trade and on land speculation. After losing much of his fortune back east during the Civil War, he returned to Kansas City and devoted himself to building railroads. With Kersey Coates he courted the Hannibal & St. Joseph Railroad, which was already planning to build a bridge across the Missouri River to Leavenworth. Robert Van Horn (below), a member of the US Congress, attached an amendment to a bill that handed the Hannibal road to Kansas City on a silver platter, leaving the citizens of Leavenworth outraged. Nevertheless, Kansas City would build the first bridge to span the Missouri River.

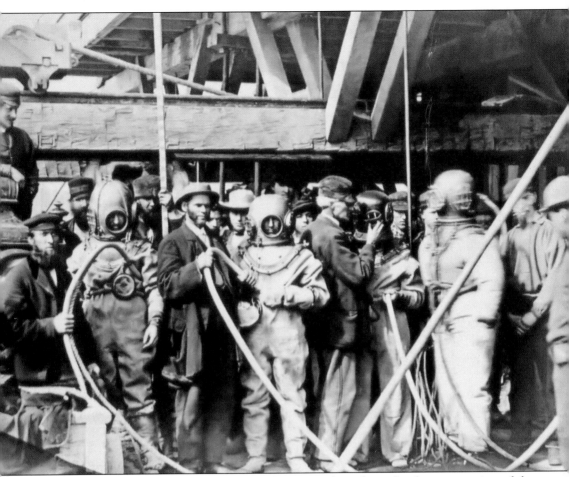

The Keystone Bridge Company from Pennsylvania was brought in for the construction of the bridge, and an abandoned building by the river was converted into a machine shop for tooling necessary parts. The bridge spanning the river had seven piers. Water-tight caissons had to be set in place by divers to allow for underwater construction, which was tedious and sometimes dangerous work that paid between $2 and $5 a day.

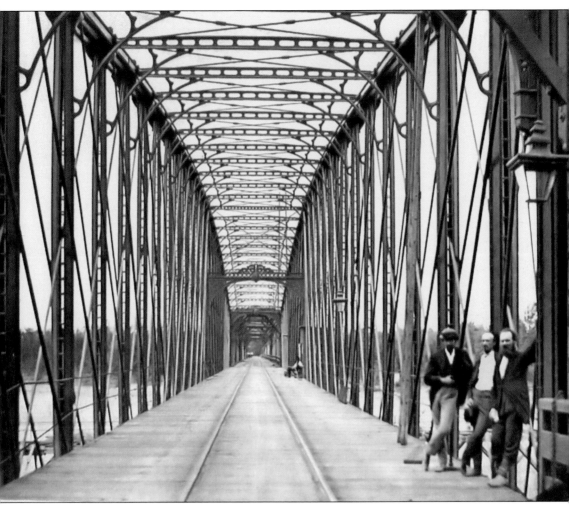

After two years and a cost of $1 million, the Kansas City Bridge (later to be called the Hannibal Bridge) was completed. It stood 50 feet above the water and was 1,371 feet long. Pictured here from left to right are assistant engineer George Morrison, Octave Chanute, and superintendent of construction Joseph Tomkinson. (MVSC.)

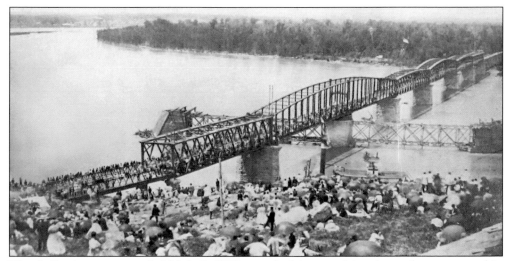

The dedication ceremony held July 3, 1869, was the biggest celebration to have occurred in Kansas City. Nearly 40,000 people, including the governors of five states and 21 mayors, came to celebrate. Banquets, bands, balls, and balloon ascensions made it the most joyous weekend in the town's history.

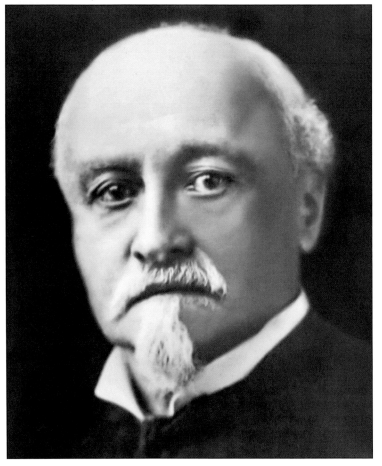

The bridge's designer, Octave Chanute, was born in Paris and came to America with his parents in 1838. After building the Kansas City Bridge, he would go on to design the Kansas City Stockyards in 1871. He is best known as a pioneer in the field of aviation and was a mentor to and close friend of the Wright brothers.

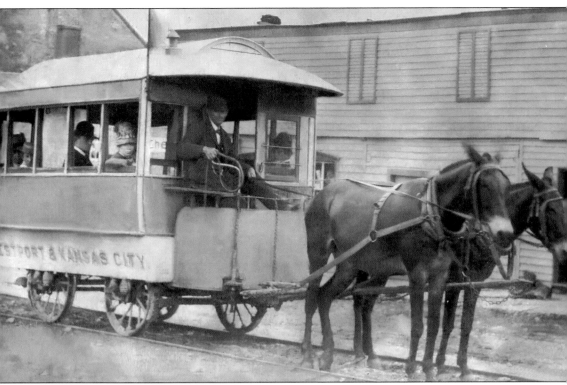

Construction on the Kansas City & Westport Horse Railroad began in 1869, and the first horse car ran on November 1, 1870. At that time, the line ran as far as Sixteenth Street, and members of the press and other prominent citizens were given a ride to the end of the line, where a celebration awaited them and they toasted the future of public transit in Kansas City.

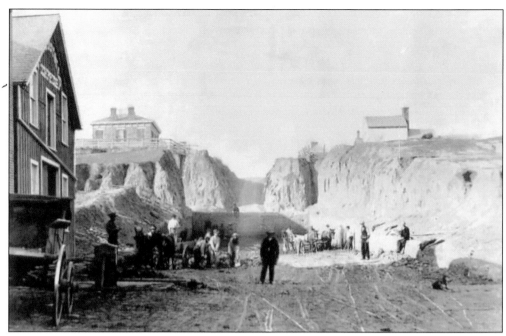

This 1868 photograph shows Walnut Street looking south between Second and Third Streets before that section of the street was graded. Many streets looked similar to this south of the levee. The street grading process would go on for more than 20 years.

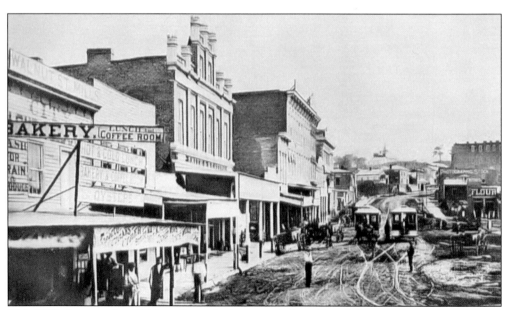

This 1872 photograph of Walnut Street looking south from Fourth Street after grading shows a much flatter landscape, with Nehemiah Holmes's horse cars going in both directions.

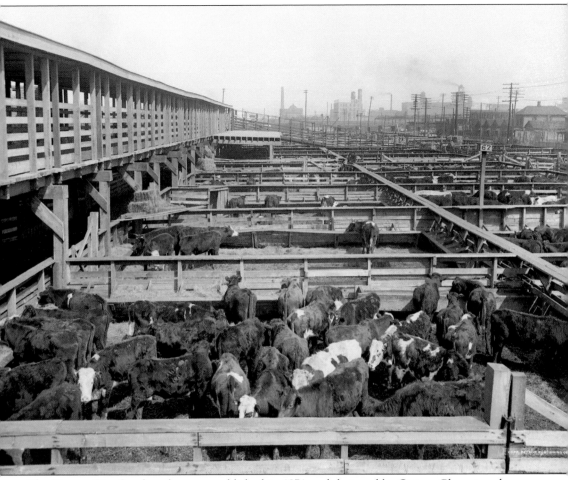

The Kansas City Stockyards were established in 1871 and designed by Octave Chanute, who a few years earlier had constructed Kansas City's Hannibal Bridge. It was built where Alexander Majors's overland freight companies outfitted, and expanded to the West Bottoms to be closer to the railroads.

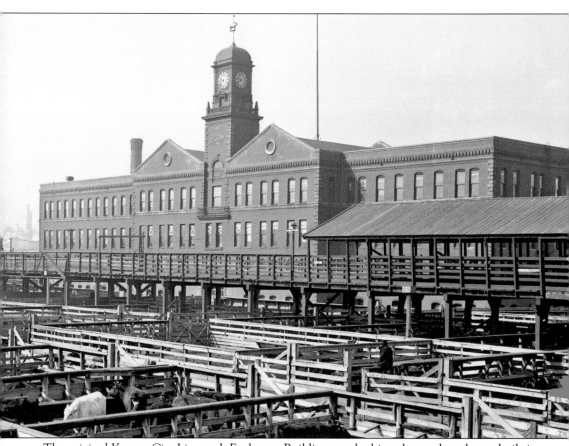

The original Kansas City Livestock Exchange Building overlooking the stockyards was built in 1871. Over the next two years, the building would triple in size, allowing for offices, two banks, a barbershop, and a billiard hall.

There were 475 offices in the livestock exchange. Besides the livestock traders, the commission agents, and the cigar sellers, the livestock exchange was where pig farmers could stock up on their Peters's Hog Serum, from their shop in the lobby.

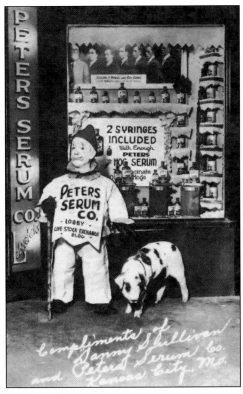

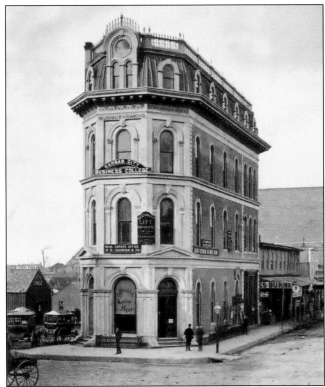

Designed by Asa Beebe Cross in 1869, Vaughan's Diamond was a four-story building at the apex of the "Junction." The building was a popular meeting place and housed a number of businesses over the years, as well as the Kansas City Medical College and the Kansas City Business School.

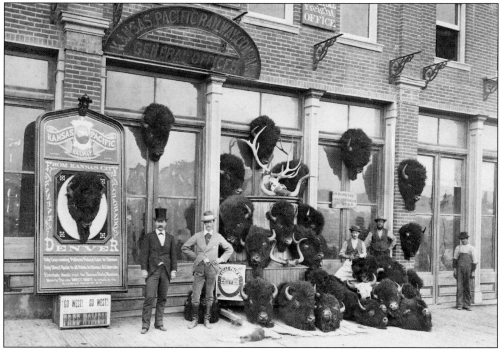

In 1864, ground was broken in Wyandotte, Kansas, for what would become the Kansas Pacific Railway. The next year, the train would be carrying passengers from Wyandotte to Lawrence, Kansas, and eventually the road would take travelers from the Kansas City area all the way to Colorado. The buffalo heads seen in the 1873 picture above were an advertising gimmick used to promote adventure in the Great West. The illustration below shows how outrageously easy it was for the railroad to obtain the heads of these animals. The railroad operated a taxidermy next to its ticket office at Fifth Street and Broadway. (Above, Southern Methodist University, Central University Libraries, DeGolyer Library; below, Library of Congress.)

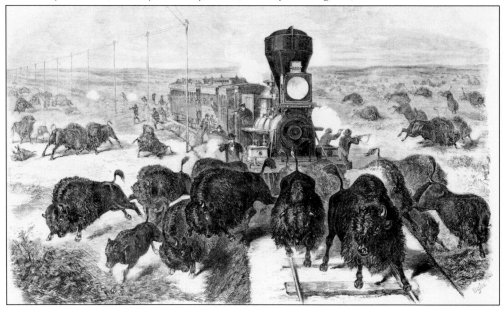

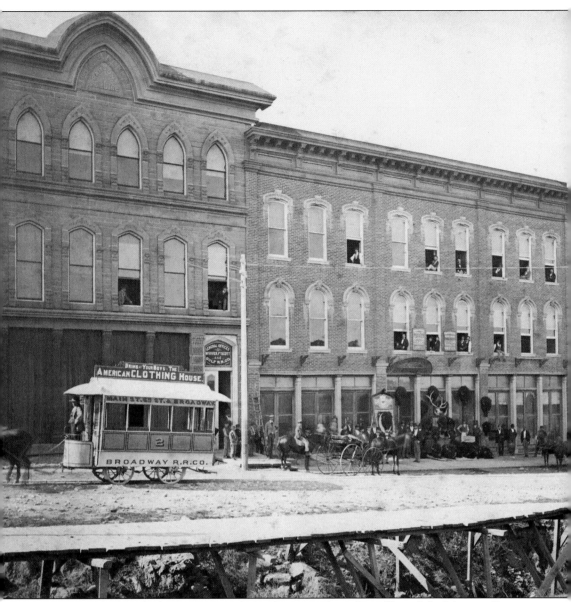

Sharing the block with the Kansas Pacific Railway was the ticket office of the Missouri River, Fort Scott & Gulf Railroad. This railroad would someday become part of the Frisco line. More railroads were either coming to Kansas City or starting from Kansas City every year, and the need for a central railroad depot would start to become desperate. (Southern Methodist University, Central University Libraries, DeGolyer Library.)

Elijah Milton McGee, James McGee's son, had his father's flair for accumulating land. He returned from California with as much gold as he could carry and used it to buy 160 acres of land south of Twelfth Street, platted as "McGee's Addition." He regularly showed up on the levee with a brass band, enticing newcomers to settle in his neighborhood. He became mayor of Kansas City in 1870.

The 1870 mayor's race was the first time Kansas City's African American population was allowed to vote. It was also the first time their vote was disenfranchised in Kansas City. According to the *Journal*, minions of Milton McGee were on hand at most polling places, with McGee himself taking an active part in making sure that white votes got counted and that black votes did not.

James Milton Turner was born into slavery in St. Louis. He served in the Union army during the Civil War, and after the war's end, Missouri governor Fletcher appointed him assistant superintendent of schools in charge of setting up public schools for African American children. He credited Robert Van Horn for donating the first schoolroom to be used for African American students, and the outlaw Jesse James for donating money to help the school operate.

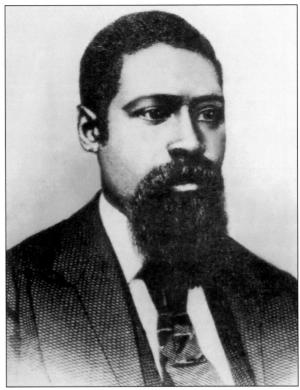

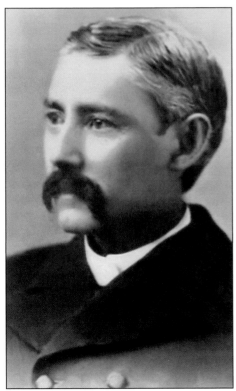

At the time James Greenwood became the superintendent of the Kansas City schools in 1874, there was a great deal of opposition to public education. Most schooling was done by religious organizations. Greenwood worked tirelessly to promote public education and improve the schools' curriculum. He remained the superintendent of the Kansas City Missouri Public School District for 40 years.

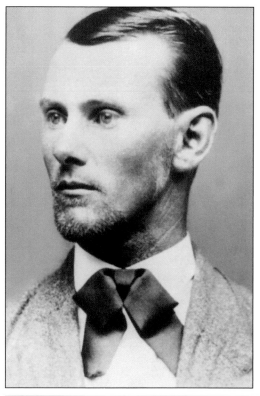

Around 1880, Jesse James brought his wife and children from Kentucky to Kansas City. Changing residences frequently, they lived in houses on East Ninth Street, on Troost Avenue, at Sixth and Walnut Streets, and on Woodland Avenue directly behind the home of County Marshal Murphy. Murphy would regularly gather a posse to search for the James Gang. Jesse, disguised with a limp, would walk over to Murphy's and wish them good luck on their trip. With a large reward on his head set by Missouri governor Crittenden of Kansas City (below), the town became too "hot" for Jesse, and he moved his family (along with the brother of his future assassin) 60 miles north to St. Joseph, Missouri, where his life as a fugitive would be ended by a bullet in 1882.

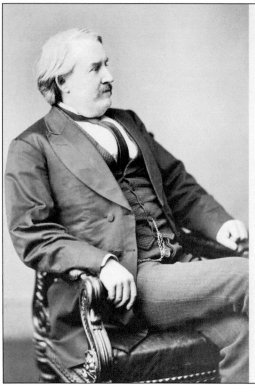

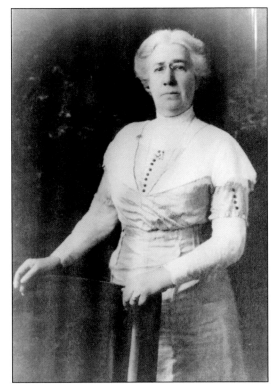

Annie Chambers, born Leannah Loveall in 1842, was Kansas City's most notorious madame. She came to Kansas City in 1869 and, in 1872, opened a luxurious two-story brothel at 201 West Third Street, two blocks from police headquarters. Her establishment operated without interference for several decades. In her old age, she turned to religion and ministered to prostitutes. (MVSC.)

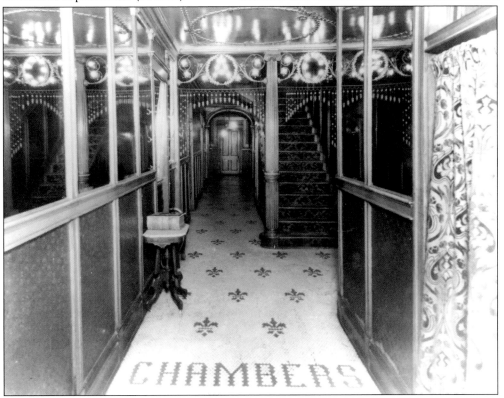

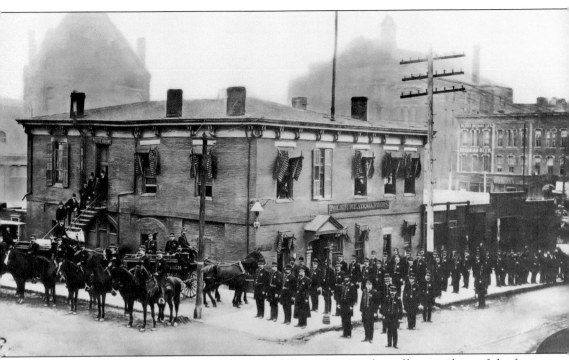

This undated photograph shows a formation of Kansas City's police officers in front of the first courthouse and police headquarters at Fourth and Main Streets. The building was originally used as the first city hall. The later city hall, which was built at the City Market, can be seen behind the police headquarters to the right. Before the Metropolitan Police Law of 1874, Kansas City's law enforcement was in the hands of elected city marshalls. J.P. Howe was elected the first city marshal in 1856. When the new police force was established, Thomas Speers was appointed the first chief of police by a board of police commissioners led by artist George Caleb Bingham. Speers would keep this job for the next 21 years, counting among his close friends men like Wyatt Earp, Wild Bill Hickock, and Buffalo Bill Cody.

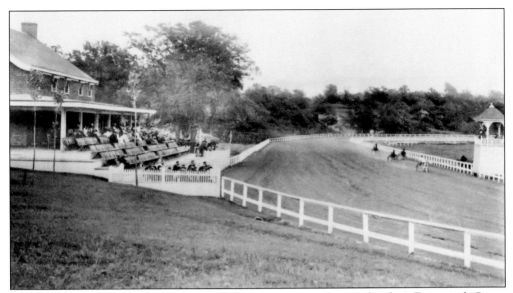

The Kansas City Horse Association leveled out some ground around today's Forty-sixth Street in 1870, and the Kansas City Driving Park was created, bringing horse racing to Kansas City. The Kansas City Driving Park would also be used for other athletic activities and, in 1907, would become the new home for Electric Park, which had outgrown its original location next to Heim's Brewery.

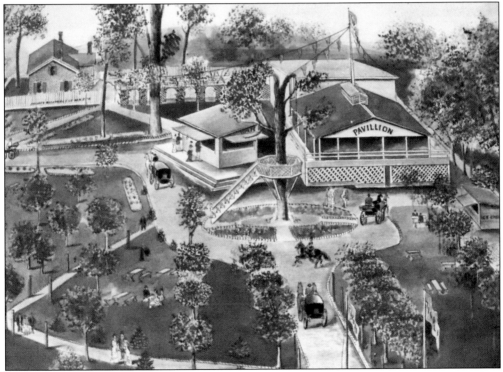

Kansas City's first amusement park was called Tivoli Garden, built by Martin Keck, whose father-in-law, Henry Helmreich, owned a brewery on the property. Martin's brother John was the town marshal who owned the Delmonico Saloon on Main Street.

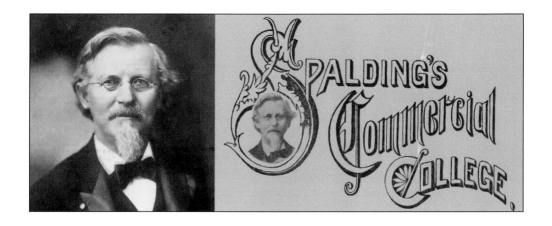

James F. Spalding was born in 1835 in Michigan. He came to Kansas City in 1865 and two years later established Spalding's Business College, later renamed Spalding's Commercial College. Here, students were taught everything from typing to banking to how to operate a printing press. Many of Kansas City's business leaders of the late 19th and early 20th centuries received their education from Spalding and his faculty. Perhaps the most famous former student of the college was US president Harry S. Truman, who learned typing, bookkeeping, and shorthand at the school in 1901. James Spalding died in 1916, but his Commercial College continued to operate in Kansas City until 1930.

In the 1870s, Kansas City was considered a playground for frontiersmen of the Wild West. Wyatt Earp, the most famous lawman of his time, enjoyed vacationing in Kansas City and hanging out at the market square with town marshal Thomas Speers. He loved the theaters, enjoyed the gambling, and made friends he would later be reunited with all throughout the west, as far away as the goldfields of Alaska.

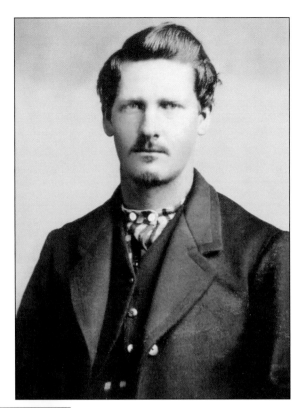

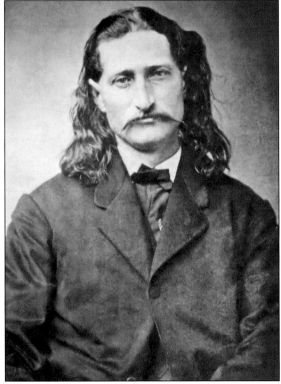

Wild Bill Hickok could be seen around Kansas City at various times in his life. He got medical help after winning a gunfight with a grizzly bear. He served as scout for General Curtis during the Battle of Westport. He umpired baseball games in the 1860s. In 1871, he lost all his money at a gambling table in Kansas City and had to take a job in Cody's Wild West show.

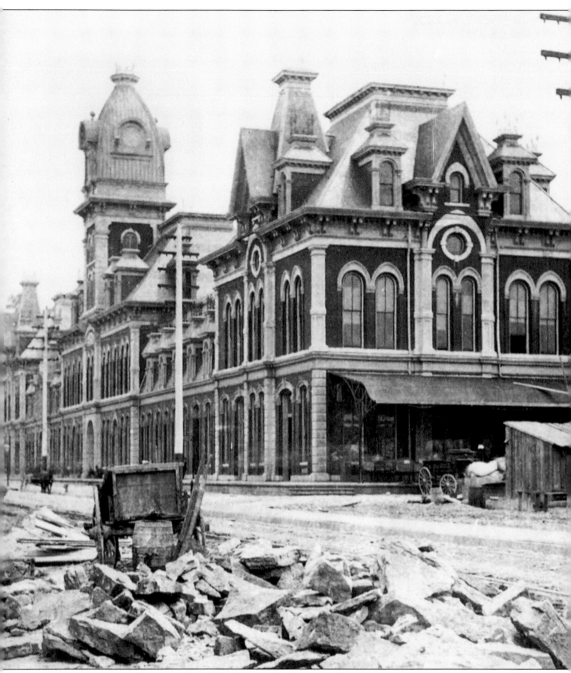

Almost 10 years after the railroad bridge was built across the Missouri River, Kansas City still did not have a central railroad station, in spite of the 10 or so railroads making their way through the town. Construction on the Union Depot, at a cost of $410,028, was finished in 1878, making it the largest railroad passenger station west of New York. Due to the population explosion that followed, Kansas City began to outgrow the new station within two years.

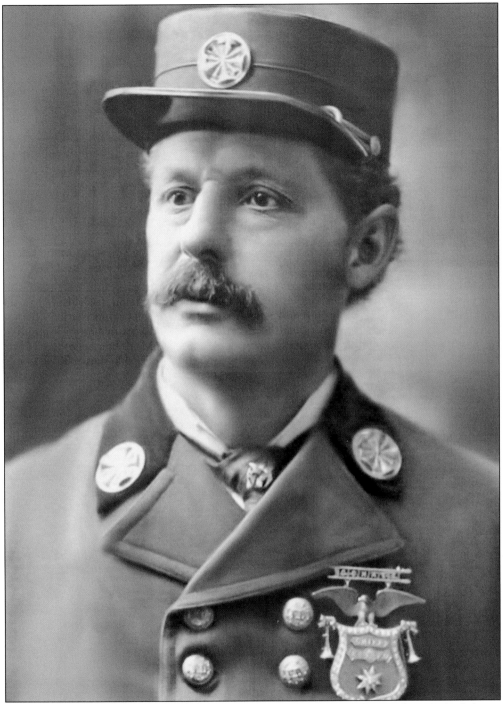

Kansas City fire chief George C. Hale was in inventor who patented more than 60 firefighting apparatuses and won awards as far away as Europe for his techniques in firefighting. He came from a family of local vaudeville entertainers, and one of his inventions was the amusement park ride "Hale's Tours and Scenes of the World," a movie venue where the motion picture career of Sam Warner began.

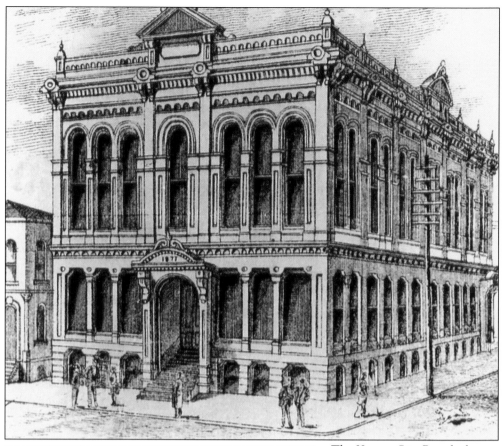

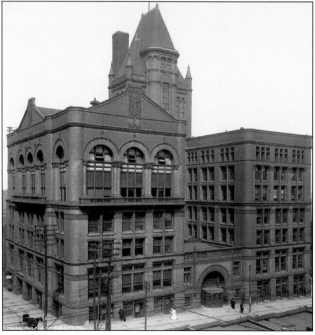

The Kansas City Board of Trade was originally called the Merchants' Exchange, organized in 1856 to serve as a chamber of commerce and a social club to advance the grain and produce interests of the city. It was not until 1872 that any actual trading took place. Formally chartered in 1876, the board had various meeting places around the city until its first Kansas City Board of Trade Building was erected on the southeast corner of Fifth Street and Delaware Avenue (above). The second Kansas City Board of Trade Building (left), at Eighth and Wyandotte Streets, was completed in 1888. Millions of bushels of grains would change hands there each year.

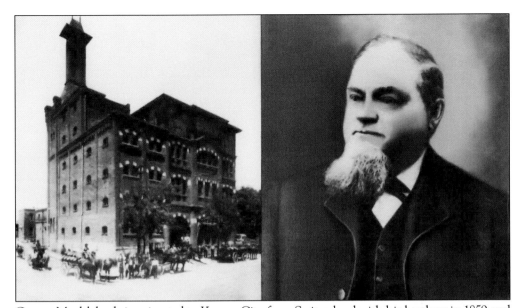

George Muehlebach immigrated to Kansas City from Switzerland with his brothers in 1859 and started a harness and saddle store in Westport. After searching for gold in Colorado, he returned to Kansas City and, in 1869, bought the Main Street Brewery from George Hierbe on Eighteenth and Main Streets, and the Muehlebach Brewery was born. By 1879, the brewery was turning out almost 4,000 barrels of beer a day.

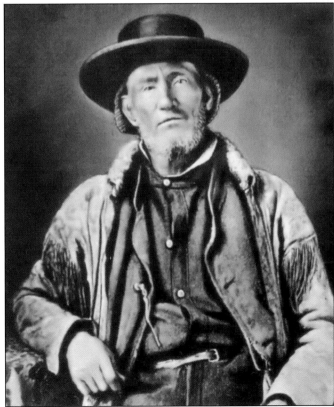

Jim Bridger was a famed mountain man, fur trapper, and expeditionary. He built Fort Bridger on the Oregon Trail close to today's town of Fort Bridger, Wyoming. Jim Bridger was a well-known and well-liked visitor to Westport during his travels. In 1866, he decided to make Westport his home and built a house there. He remained until his death in 1881.

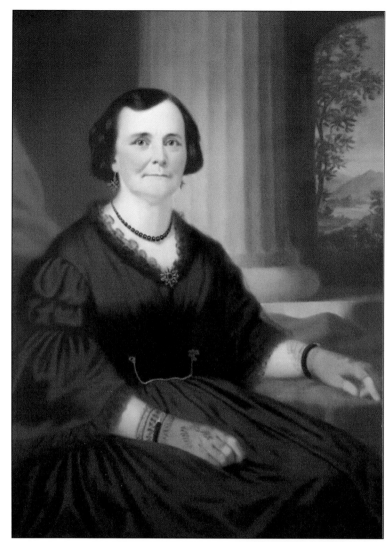

Mary (née Kennerly) Troost, the widow of Dr. Benoist Troost who died in 1959, was left a fortune by her uncle (and late husband's business partner) William Gillis. When she died in 1873, her will directed that the estate she left behind should be used to build a grand theater, and that the proceeds from the theater be used to help the community's orphans. (George Caleb Bingham.)

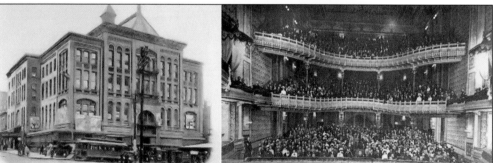

The $140,000 Gillis Opera House at Fifth and Walnut Streets was finally completed and opened to much public fanfare on September 10, 1883. The most famous theater and opera acts in the world performed at the Gillis Opera House, which had ticket prices ranging from 50¢ to $20. The theater raised money to support the Gillis Orphanage until 1924, when an explosion destroyed the theater.

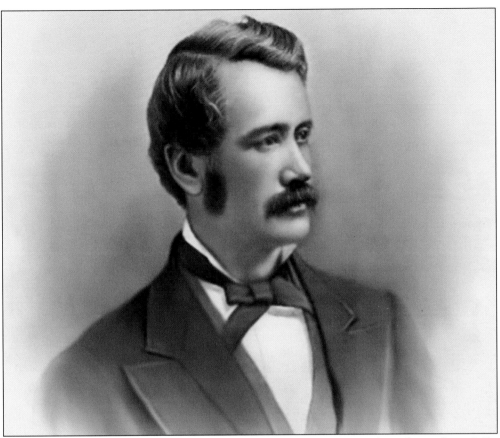

Thomas Bullene came to town in 1863 to buy out William Gillis's stock in the outfitter Gillis and Coates, Gillis having been barred from the business on account of Confederate sympathies. Bullene and Coates would eventually evolve into the retail empire Emery, Bird, Thayer Co., the largest dry goods store west of the Mississippi (below). Bullene's store was the first in Kansas City to use steam-powered elevators and gas lighting, and he was famously known as the "Merchant Prince of the Missouri Valley." Bullene was the first president of the Kansas City Humane Society and, in 1888, he became Kansas City's 22nd mayor. Though rarely credited for it, Bullene was one of the driving forces behind establishing the parks board that would usher in the City Beautiful movement and bring hundreds of miles of boulevards to the city.

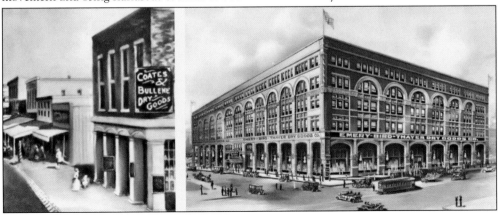

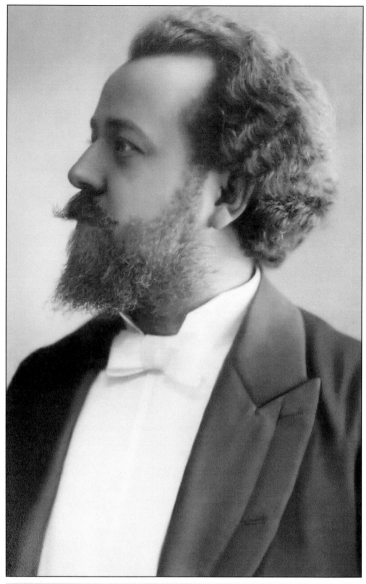

(Sir) Carl Busch learned to play the flute, violin, and cello growing up in Denmark. He came to Kansas City in 1887, and he and his Kansas City bride, Sallie Smith, taught music while he honed his skills as a composer. In 1895, Kansas City's Philharmonic Orchestra was organized, with Carl Busch as its director. Busch was regaled as Kansas City's foremost composer and conductor. In 1911, the Kansas City Symphony Orchestra was born under his direction. In 1912, the king of Denmark knighted him, and he became Sir Carl Busch. Throughout his career he continued teaching, being invited to work for universities and music schools throughout the United States, and was one of the first faculty members of the University of Missouri, Kansas City. Busch passed away in Kansas City in 1949.

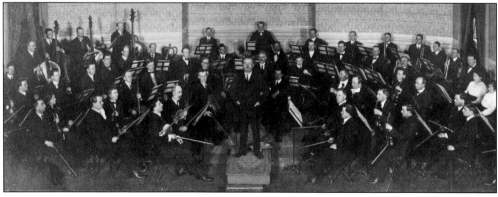

Willard E. Winner began his career as a postal clerk but would soon become an investment pioneer, owning some 20,000 acres of land in Kansas City's tri-county area, including some of the most prized real estate in Downtown Kansas City. He created the city's first electric streetcar line, began construction on the first vehicle and pedestrian bridge across the Missouri River, and built a steam rail system that connected Kansas City to Liberty and Independence. Once one of the wealthiest men in Kansas City, he lost his entire fortune during the banking and real estate bust of the 1890s. Though many of the projects he began were completed by others (including the ASB bridge), Winner died a poor man in 1929 at the age of 80.

Theodore Case, the Civil War quartermaster, became famous as a writer and scientist, teaching chemistry at the Kansas City Medical College and publishing the *Kansas City Review of Science and Industry*. When excavation began for the Emery, Bird, Thayer Co. Building, he collected and categorized the hundreds of fossils and artifacts that were unearthed. In 1888, he published a 726-page history of Kansas City, a comprehensive work still referenced by historians today.

Five

A CITY BEAUTIFUL

Throughout the 1880s and 1890s international exhibitions, popularly known as World's Fairs, were held throughout the United States and around the world, with their design and grandiosity increasing every year. In the United States, individual states and companies would set up displays at these exhibitions, each trying to out-do all of the other exhibitors in the splendor and magnificence that they represented to the world. Visitors to these exhibitions would thrill to the experience of seeing makeshift castles and mansions as they strolled along beautifully groomed grounds with fountains and lights. Then they would return to their own 19th-century towns, most of which were teeming with poverty and blight due to an economic downturn. Throughout the world, urban areas were clamoring to beautify their surroundings, and Kansas City was at the forefront of what 10 years later would be called the City Beautiful movement.

Most people credit the City Beautiful movement as starting at the World's Columbian Exposition in Chicago in 1893, but in Kansas City the movement was started long before that. Kersey Coates lobbied for public parks since 1856, but the Civil War and the recovery afterward changed everyone's priorities.

When Thomas Bullene sat on the city council in the late 1870s and served as mayor beginning in 1882, the idea was already being talked about, but talk was about as far as it went. The people liked the idea of public parks, but they did not like the idea of being taxed to pay for the land to build the parks on. In the 1889 Kansas City Charter, Judge John K. Cravens added a special article relating to public parks, but the courts struck the special article. Nonetheless, in 1892, Mayor Benjamin Holmes appointed a parks board that gave the city a detailed report about how to implement a system of parks scattered throughout the city, "strung together" by beautifully landscaped boulevards. The paid secretary (but unpaid engineer) was a man named George Kessler, a landscape architect who had done beautiful work in Hyde Park and would design a system of boulevards and parks in Kansas City that would make him famous throughout the world.

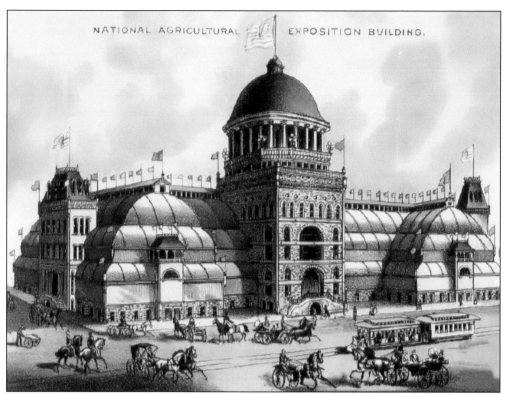

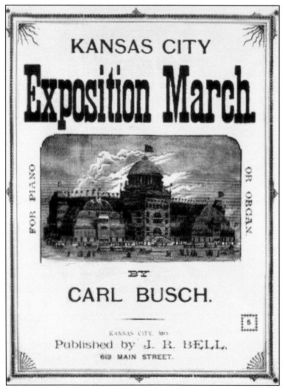

The Exposition Building was built in 1887 from Twelfth to Fifteenth Streets near Kansas Avenue to answer the growing need for indoor space to house the wildly popular exhibitions that were given over the course of weeks each year. Also known as the "Crystal Palace," the building featured an 80,000-square-foot glass roof. Modeled after the Crystal Palace in London, the building would sometimes receive 60,000 visitors in one day during exhibitions. In 1887, one of those guests was Pres. Grover Cleveland.

The "Exposition March" was a tribute to the Crystal Palace composed by Kansas City's then up-and-coming musical maestro Carl Busch, who would someday lead the Kansas City Symphony with the title Sir Carl Busch, having been knighted by the king of Denmark.

George Woodward Warder was a Kansas City attorney with banking and real estate interests, as well as a penchant for poetry and philosophy. He published several books during his lifetime, some of poetry and others devoted to his theories about cosmology and the role electricity played in the creation of the universe. After being insulted by a theater owner, Warder built the Warder Grand Opera House (below) in 1888. It was an ambitious and beautiful venue but proved to be a financial disaster for Warder, who lost control of the enterprise in 1890 and found himself deep in debt, never to regain his fortune. He continued writing books until a few years before his death in 1907.

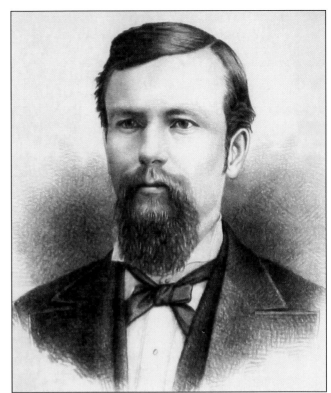

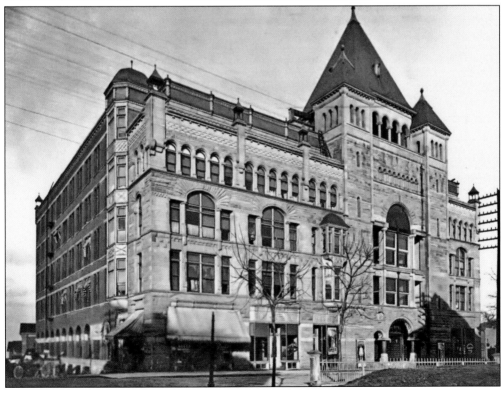

Kansas City's first library was established in 1873 with a set of encyclopedias sitting on a single bookshelf. In 1889, it got its own building at Eighth and Oak Streets. In 1897, this $200,000 building at Ninth and Locust Streets was opened to the public, housing not only books but also an art gallery and museum artifacts. The building remained the central branch of the library until 1960.

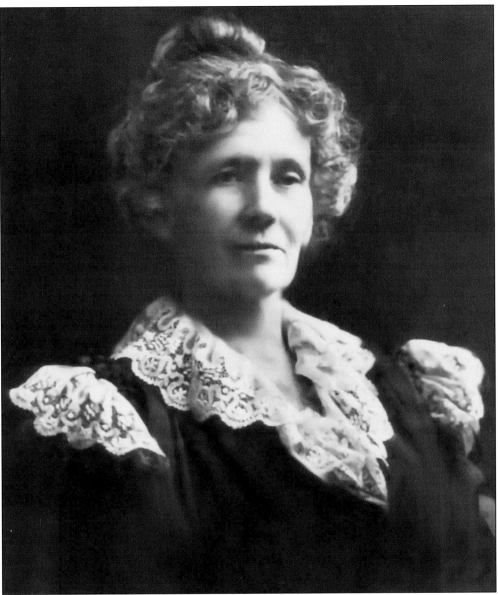

Carrie Westlake Whitney was called the "Mother of the Kansas City Public Library." She lobbied for bigger buildings, more books, and more services. During her time in charge of the library, the number of books grew from 1,000 to 100,000. In 1908, she published the most comprehensive history of Kansas City up to that time, a three volume work called *Kansas City, Missouri: Its History and Its People, 1800–1908*. In 1911 she was demoted by the school board, which insisted that only a man should hold a position that prominent.

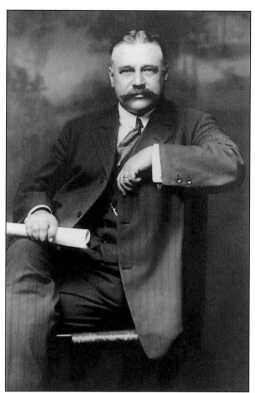

George Kessler was a German immigrant, later returning to Europe to study landscape design. In 1890, he was hired by the newly formed parks board to design Kansas City's boulevard system. His work in Kansas City drew attention around the world, and he was hired to design the grounds for the St. Louis World's Fair. Later, he was commissioned to work in cities as far away as Mexico City and Shanghai.

In April 1893, the parks board delivered a report to Mayor Cowherd, along with this map of proposed parks and boulevards. Members of the board were architect Adriance Van Brunt; August Meyer, smelting factory owner; Simeon Armour of Armour Meatpacking; Louis Hammerslough, popular clothier; and William C. Glass, a liquor and cigar wholesaler. George Kessler was officially hired as a secretary for $100 a month, the city being unable to afford a landscape architect.

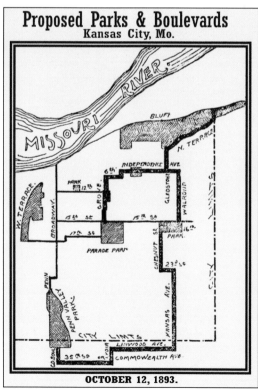

Proposed Parks & Boulevards
Kansas City, Mo.

OCTOBER 12, 1893.

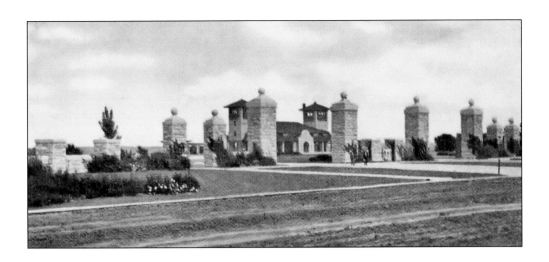

Adriance Van Brunt came to Kansas City from New Jersey in 1878 and opened an architectural firm with his brother. A. Van Brunt & Co. built numerous houses and commercial properties during the building boom of the 1880s. Van Brunt was a member of the first parks board and, in 1892, toured east coast cities with Mayor Benjamin Holmes to get ideas for laying out Kansas City's own scenic boulevard system. He designed many of the park buildings and shelters, including the entrance to Swope Park (above).

Parks board member August Meyer came to Kansas City in 1881 and opened a smelting plant after making a fortune crushing ore in Colorado. He started lobbying the city for a public parks plan in 1887 and was one of the presidents of the parks board. His mansion, below, is now called Vanderslice Hall and serves as the administrative offices of the Kansas City Art Institute. Meyer Boulevard was named in his honor after his death in 1905. (Kansas City Art Institute.)

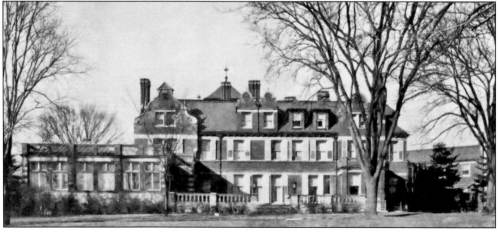

The above image shows the work being done to beautify the Paseo at Seventeenth Street. The picture below shows the finished result.

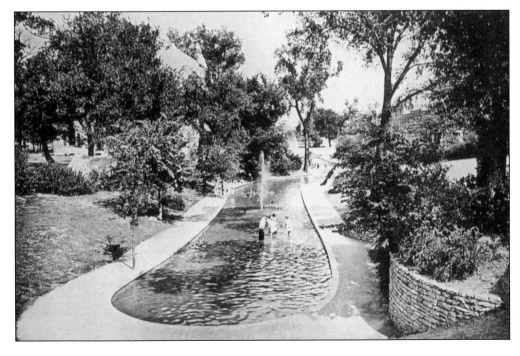

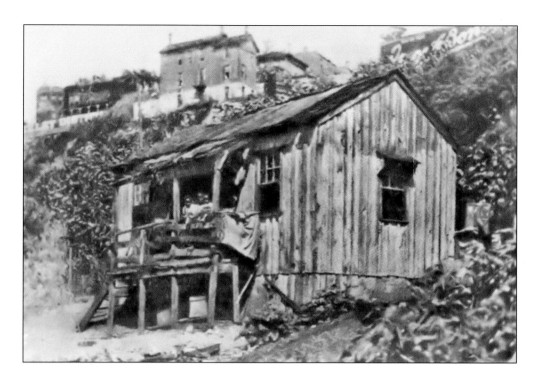

The ramshackle bluffs in the picture above were cleared away to turn the hill into the Pallisades, below, that led to West Terrace Park, one of the parks board's first projects. This stretch of Seventeenth Street was known as Kersey Coates Drive, named after one of the town's most important settlers. Kersey Coates Drive and the Pallisades were taken over by the interstate highway system in the 1950s. West Terrace Park remains today.

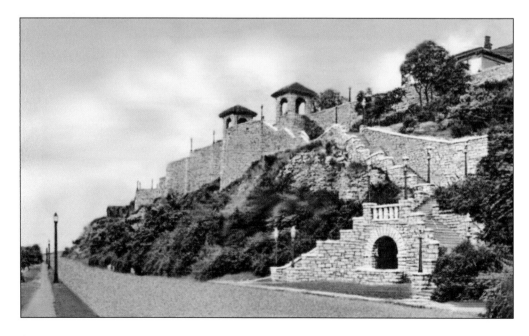

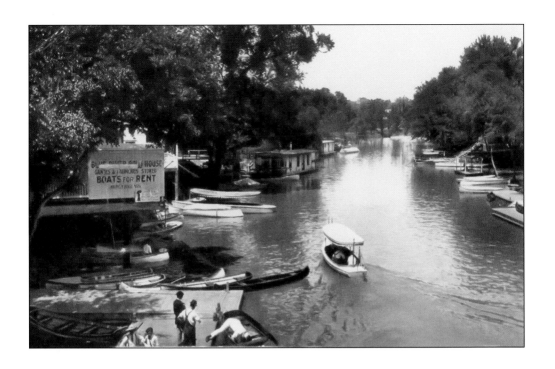

The Blue River ran as a transportation route through Kansas City from as far south as Leeds north to the mouth of the Missouri River at Sheffield, though it was generally used for fishing and recreational purposes. Houseboats and cottages lined the river, mostly used in the summertime but sometimes year-round.

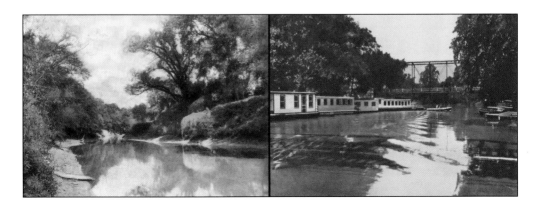

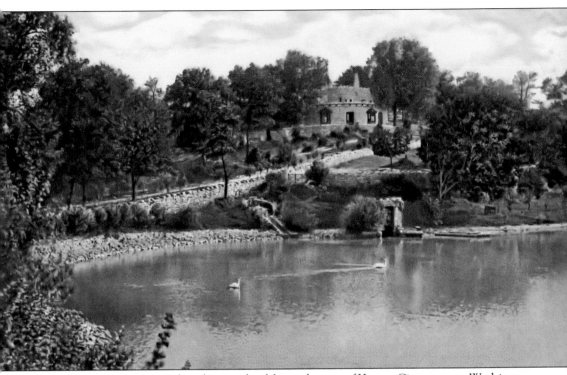

Willard Winner's company bought some land five miles east of Kansas City to create Washington Park, which sat on 382 acres of what the *Kansas City Times* would call "the most picturesque spot between the Allegheny Mountains and the Rockies." Surrounding the 20-acre "Swan Lake" were picnic grounds, a castle, a ball field, amusements, dancing, camping, and more. The park could be reached by horse car at first, then later by streetcar. Soon another amusement park would move close by, and the competition proved too much. Within 10 years, Washington Park would become Mt. Washington Cemetery, a beautiful resting place designed by famed landscape architect George Kessler. The cemetery was very popular with some of Kansas City's most prominent residents, who saw it as a lovely alternative to the overcrowded Elmwood Cemetery. Jim Bridger, James A. Reed, and William Rockhill Nelson are but a few historic Kansas City figures laid to rest there.

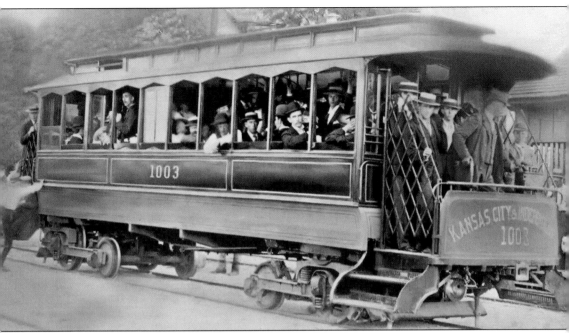

Not only did Willard Winner's Kansas City Independence Street Railway bring thousands of amusement-seekers to Washington Park, it also helped to create the road from which the communities of Englewood and Maywood would spring up, which can now be found along Winner Road.

Arthur Edward Stilwell

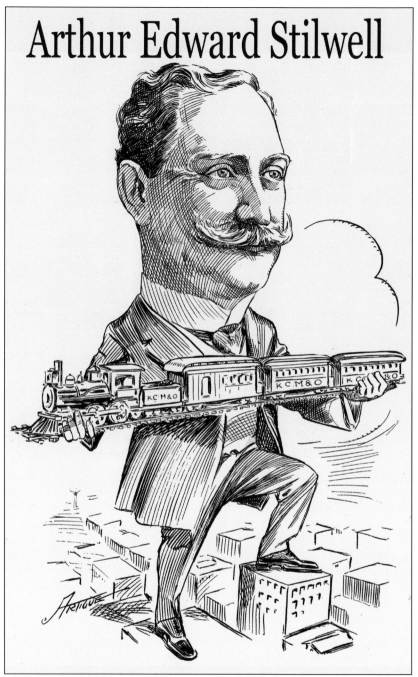

Arthur Edward Stilwell was a promoter with vision. He dreamed up big ideas, then traveled the world to find the money to turn his dreams into reality. Born in Buffalo, New York, in 1859, he married his childhood sweetheart, Jennie, and then set about to make his fortune. He started his career in printing and sales. By the time the Stilwells settled in Kansas City in 1886, Stilwell brought with him $25,000 he had earned from innovating life insurance policies for Traveler's Insurance in Chicago. Once here, he began in real estate, then turned his eye toward railroads, helping build the Kansas City Suburban Belt Railway, a rail line that encircled the city.

Besides the Suburban Belt Railway, Arthur Stilwell owned the construction company that was building a depot closer to the river, at Second and Wyandotte Streets. From this depot, he would run another streetcar line, the Air Line, that would take people to a new project he was working on.

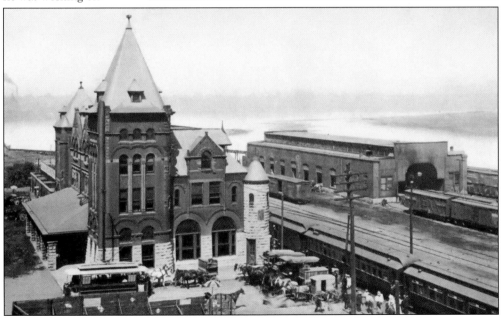

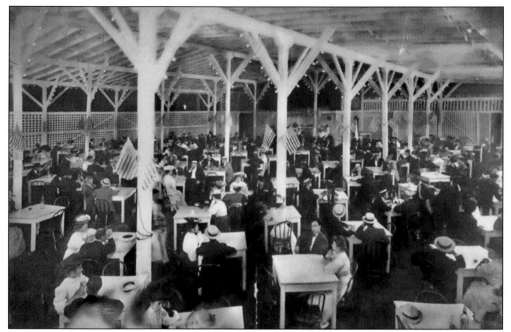

Fairmount Park was built by Arthur Stilwell at the end of his Air Line streetcar road as a way to increase ridership. Featuring a 40-acre lake, an outdoor theater, and amusement park rides, it soon put Willard Winner's Washington Park out of business. Hot-air balloon races were a common feature. The Kansas City Athletic Club and the Kansas City Horse Show began at Fairmount Park.

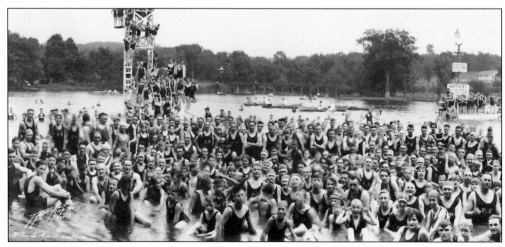

Swimming was a top attraction at Fairmount Park. Swimming suits were rented for 10¢ a day, and rowboats for a quarter. Swimming lessons were given in the morning, and swimming races drew hundreds of competitors and sometimes thousands of gamblers to the lake each weekend. Weekend fireworks over the lake added to the swimming hole's appeal.

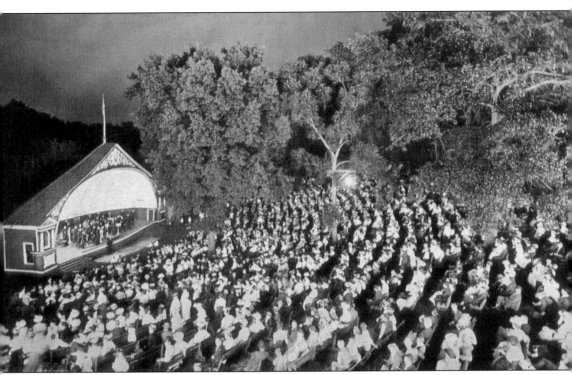

Fairmount Park's outdoor amphitheater, called the Theater in the Woods, featured some of the best summertime entertainment in Kansas City. Top orchestras and entertainers performed there, and some of the best vaudeville acts in the country graced its stage. (Library of Congress.)

COME AND SEE WHERE AN EMPIRE IS BUILDING

PASSENGER STATION AT KANSAS CITY

COAL, MINES AND BREAKERS IN CHEROKEE DISTRICT

ZINC SMELTERS, PITTSBURG, KANS.

AN OZARK APPLE TREE NEAR GENTRY, ARK.

CORN	**KANSAS CITY**
WHEAT	
CATTLE BREEDING	
COAL	AMORET
OATS	
RYE	
FLAX	
COAL	PITTSBURG
LEAD	
ZINC	JOPLIN
BIG RED APPLES	
PEACHES	GOODMAN
OAK	SULPHUR SPRINGS
MARBLE	GENTRY
ONYX	SILOAM SPRINGS
HICKORY	STILWELL
GRANITE	
FRUIT	SALISAW
SEMI-ANTHRACITE COAL	POTEAU
BITUMINOUS COAL	
LEAD	MENA
ZINC	
COPPER	JANSSEN
MANGANESE	DE QUEEN
COTTON	
GYPSUM	
PEACHES	
SHORT LEAF PINE	TEXARKANA
COTTON	
LONG LEAF YELLOW	SHREVEPORT
PINE	
SHIP TIMBER	HORNBECK
COTTON	
FIGS	
SUGAR	DE QUINCY
RICE	
GARDEN TRUCK	BEAUMONT
PEARS AND SMALL FRUITS	LAKE CHARLES
	PORT ARTHUR

The Port Arthur Route

Connects Kansas City, the center of the district, whence comes 90 per cent. of the export food products of the United States, with our Gulf Terminus, Port Arthur, by a 788 mile air line— shortest to tide water.

Financed and built during the recent business depression.

The building of this road has created wonderful prosperity throughout its rich, but heretofore remote, tributary region ; the superior location of this road insures the permanence of this prosperity. Add National Prosperity and you will get an idea of the marvelously bright future of this great wealth producing section.

Is it not worth while for you to make a trip this fall to see this Empire building ?

H. C. ORR, A. E. STILWELL,
Gen. Pass. Agt. Prest.
Kansas City, Pittsburg & Gulf R.R.
Kansas City, Mo.

PEACH ORCHARD. $25 PER ACRE INVESTED IN PLANTING YIELDS $300 PER ANNUM AFTER FOUR YEARS

VIEW NEAR SULPHUR SPRINGS

MT. MENA, THE HIGHEST MOUNTAIN BETWEEN THE ROCKIES AND THE ALLEGHENIE

SCENE AT MENA, ARK. Sixteen Months ago a Forest, it now has 2500 people

STEEL BRIDGE OVER THE ARKANSAS RIVER 15 Miles west of FORT SMITH

PASSENGER STATION AT PORT ARTHUR

HOTEL SABINE, PORT ARTHUR.

LOUISIANA LONG LEAF PINE ITS NATURAL GROWTH ADDS 80 PER CENT TO ITS VALUE EVERY YEAR

Stilwell's plan to create a railroad from Kansas City to the Gulf of Mexico drew investors from as far away as Europe, and dozens of new cities were created along the line. Stilwell named some of the towns after himself, but others were named after his investors.

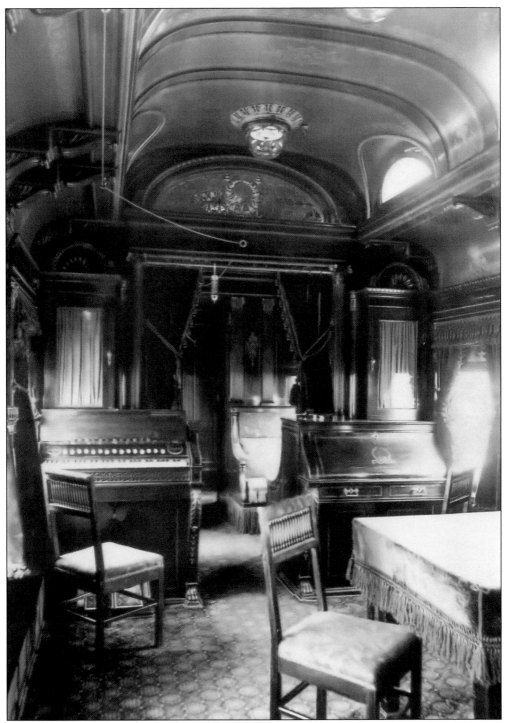

Stillwell's Port Arthur cars were resplendent in mahogany and velvet, furnished with an escritoire and an organ. Stilwell was fond of singing hymns. When traveling with his investors who were posing questions, Arthur would reply with, "Before I answer that, let's sing a hymn." By the time the hymn-singing was over, the investors often forgot about their questions.

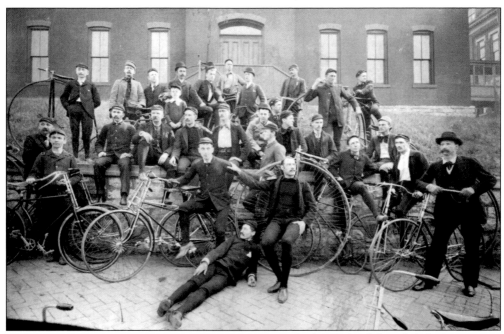

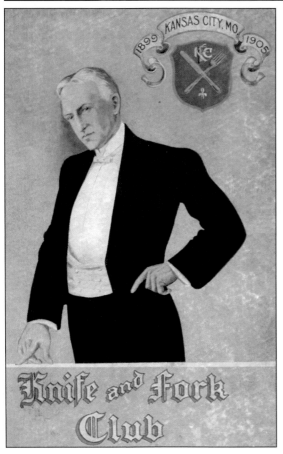

Arthur Stilwell founded the Fairmount Cycling Club in the early 1890s. This organization would eventually evolve into the Kansas City Athletic Club.

Kansas City's Knife and Fork Club was organized in 1899 and held monthly meetings for elite businessmen in Kansas City, featuring world-famous speakers and politicians, as well as world-class menus.

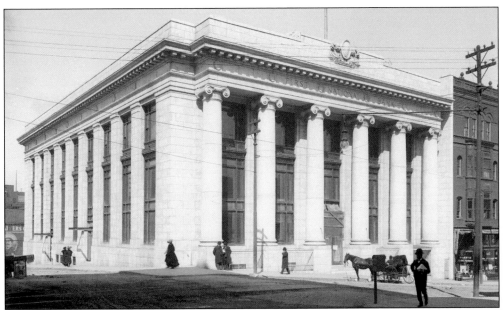

Col. James Abernathy and James Lombard opened the original First National Bank of Kansas City at the Junction in 1886. In 1891, they moved it to the eight-story Heist Building (right), on Main and Eighth Streets. By 1906, it had outgrown those offices, and the impressive marble and mahogany-filled building at Tenth and Baltimore, which today houses the Kansas City Missouri Public Library (above), was constructed.

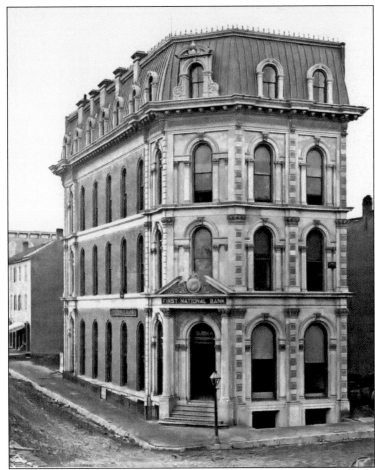

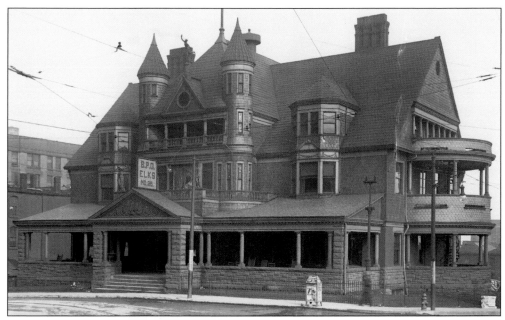

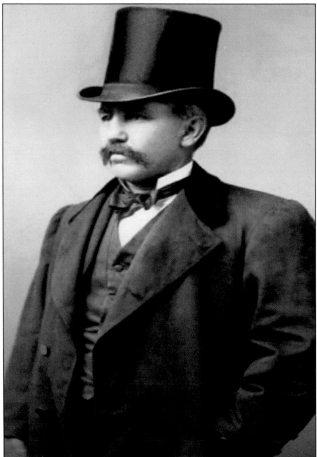

Kansas City's home for the Benevolent and Protective Order of Elks was built in Chicago and used for the 1893 World's Fair to represent the state of Wisconsin. After the fair, Kansas banker James C. Rogers bought the building and had it disassembled, moved to Kansas City, and reassembled at the northwest corner of Seventh Street and Grand Avenue.

Asa Beebe Cross was Kansas City's first professional architect. He arrived in Kansas City in 1858 as a lumberman, and in the 1870s gained fame for his designs of the Vaughan Diamond Building and the Union Depot. He would eventually oversee the building of more than 1,000 of his designs in the area. The Vaille Mansion in Independence and St Patrick's Catholic Church in Kansas City are two of the few structures that remain to show the magnitude of his talent and imagination.

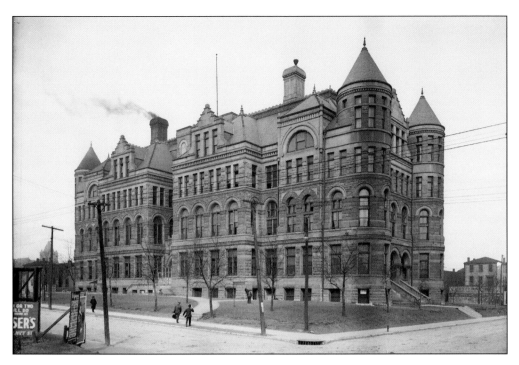

The Jackson County Courthouse (above) was built in 1892 to replace one built in 1868 that was destroyed by a tornado. This courthouse, designed by Asa Beebe Cross, occupied an entire square block on Fifth Street and Locust Avenue. Below is City Hall at Fourth and Main Streets, also designed by Cross, and built in 1891.

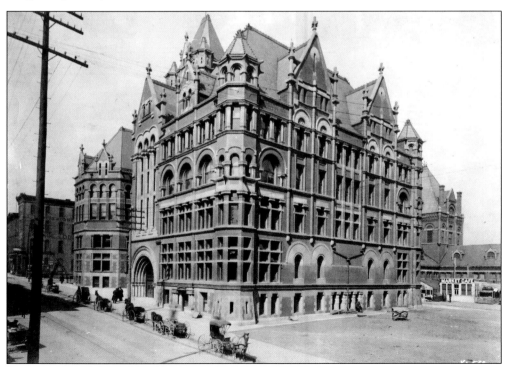

Robert Alexander Long was a lumber and coal baron whose business empire was headquartered in Columbus, Kansas, but he made Kansas City his home in 1891. His company, Long-Bell Lumber, had holdings in states from Louisiana to Washington.

Shown here is a train carload of "big timbers" stamped with the Long-Bell trademark ready for shipment, making its way from one of Long-Bell's logging camps to be used for heavy construction somewhere in the growing America.

R.A. Long built Kansas City's first steel framed skyscraper in 1907 at Tenth Street and Grand Avenue. It was 16 stories high, with 600 offices. The Federal Reserve Bank was housed in the R.A. Long Building from 1914 to 1921, and the building would later become headquarters of the United Missouri Bank.

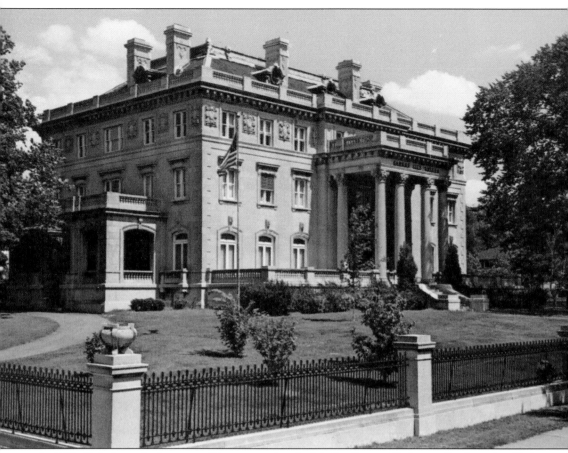

In 1910, R.A. Long built a magnificent mansion for his family on Gladstone Boulevard, called Corinthian Hall. Corinthian Hall now houses the Kansas City Museum. After this, he built the Longview Mansion along with 50 other farm structures in Lee's Summit between 1913 and 1914, with George Kessler in charge of the landscape design. Part of his land was donated to the community and is now the home of Longview Community College.

Six

CHANGING CENTURIES

With city beautification underway and an improving economy, Kansas City looked toward the new century with growing enthusiasm. Westport was officially chartered and was now part of Kansas City. Theaters dotted the community offering everything from opera to vaudeville, and streetcars could transport city residents to places as far away as Excelsior Springs and St. Joseph. Technology was improving and gave city residents a glimpse of what the 20th century would be like. Many homes had telephones, and automobiles were now sharing the roads with the horses and buggies and streetcars. Railroad travel and business at the Livestock Exchange was booming like never before. But the city needed something more.

Arthur Stilwell first conceived of a giant convention venue and became chairman of a committee to raise funds for the building of the future Convention Hall. With his Kansas City, Pittsburg & Gulf Railway well underway, he knew that visitors would be coming to town in numbers never seen before and, with its central location, he envisioned Kansas City as the "Convention Capitol of America." 1900 would usher in not only a new century but also a new era in Kansas City history.

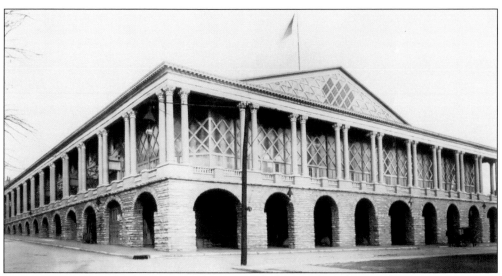

Convention Hall was built in 1899 at the corner of Thirteenth and Central Streets. The project cost $225,000, raised by selling bonds and through the fundraising efforts of Arthur Stilwell's Kansas City Admirers, organized in 1897. The Admirers sold "Convention Hall Buttons," good for one share of stock and also perks around Kansas City such as free streetcar rides to Stilwell's Fairmount Park. (MVSC.)

The first use of Convention Hall, though still unfinished, was for a meeting of Republicans on October 8, 1898. The first piece of music played in the Hall was "The Kansas City Journal March." On February 22, 1899, Convention Hall was officially dedicated, with the grandest ball the town had ever seen. Tens of thousands gathered in and around the hall, and to everyone's surprise, John Philip Sousa's band appeared and opened the festivities with the legendary march, "Stars and Stripes Forever."

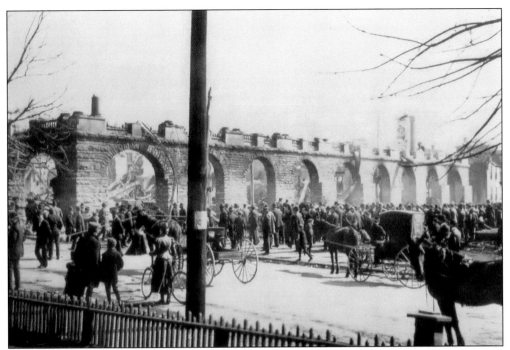

Ninety days before the 1900 Democratic National Convention was scheduled to be held at Convention Hall, fire completely destroyed the building. Kansas City mourned, but not for long. Immediately, efforts were put into place to rebuild the hall, and the community worked together night and day to get the new Convention Hall ready in time for the national gathering. (MVSC.)

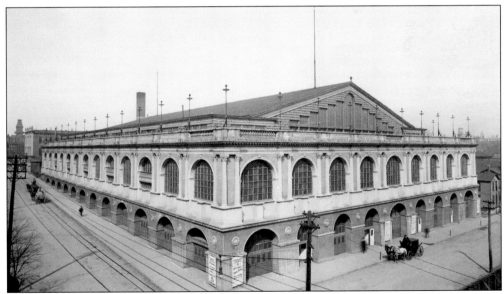

The second convention hall was completed just in time for the Democratic National Convention. Mustering the citizens was Arthur Stilwell, who was even more successful bringing the community together the second time around.

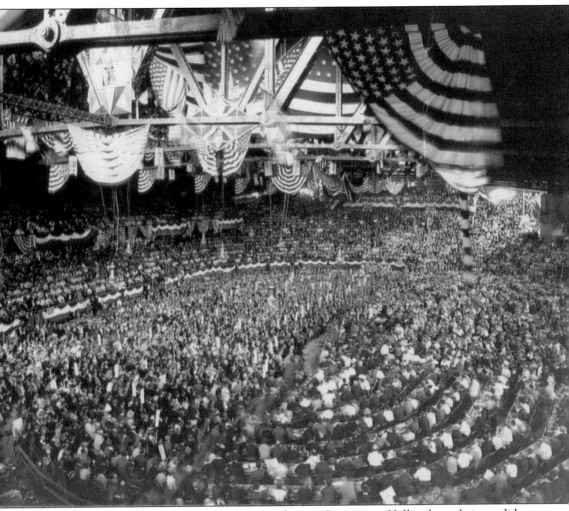

Democrats from around the country gathered at the new Convention Hall and saw their candidate William Jennings Bryan accept the nomination. Young Harry S. Truman served as a page at this convention.

Jesse James Jr., the son of the outlaw, grew up in Kansas City and was taken under the wing of the son of the governor who had ordered the arrest (or killing) of Jesse James. As a young man with a good name and reputation, Jesse Jr. found himself arrested and charged with train robbery. He would go on to become a lawyer and actually played the role of his father in two silent movies in the early 1920s.

James A. Reed prosecuted Jesse James in his trial for train robbery. The next year, he was elected mayor of Kansas City. It was a stepping-stone on the ladder of political success that would take him all the way to the US Senate. His decision as a member of the Senate Banking Committee to change his vote broke a deadlock that allowed for the passage of the Federal Reserve Act; as a reward, Missouri is the only state to have two Federal Reserve Banks.

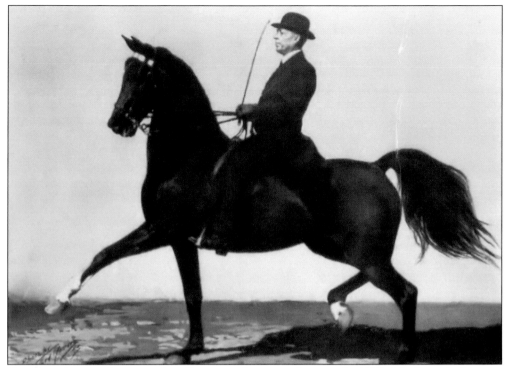

Tom Bass, the son of a slave girl and her master's son, was born in the 1850s. He showed adeptness for horses at an early age. When he came to Kansas City in the 1890s to start his own stable, he had several world championships to his credit. Sitting on the board of advisers of the fire department, he suggested a horse show as a way to raise money. What started off as Bass's fundraising horse show at Fairmount Park evolved into today's American Royal.

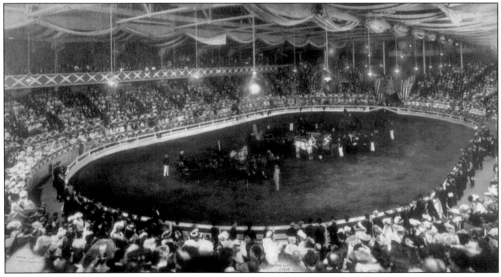

In 1905, the Kansas City Horse Show was moved to Convention Hall and became part of the American Royal, an eight-week-long celebration held every year since 1899. The American Royal features a livestock show, the horse show, a rodeo, and barbecue competitions that bring visitors to town from around the world.

Lafayette Tillman was born in Indiana and was an accomplished singer who performed at the White House before coming to Kansas City in 1880 and opening a restaurant. In 1889, he opened a barbershop for white patrons at Twelfth and Grand, became a notary public, and began studying at the Kansas City School of Law. He was known as a leader in Kansas City's African American Community.

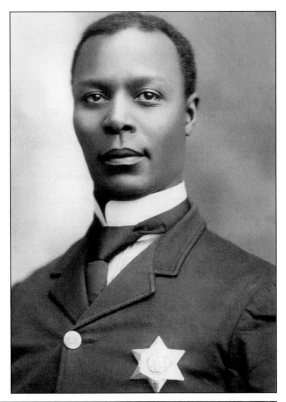

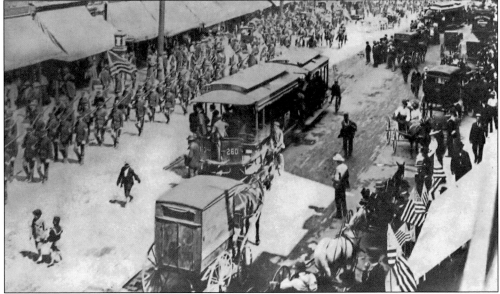

When the Spanish-American War broke out, Tillman enlisted in the US Army and achieved the rank of first lieutenant in the 49th Infantry Regiment. From 1899 to 1902, his company battled against Philippine insurgents, and upon his return to Kansas City, he was welcomed as a war hero. Kansas City honored his service by making him the second African American policeman in the city's history, a job that he held until his death in 1914. At the time of his death, he was one of the oldest police officers on the force.

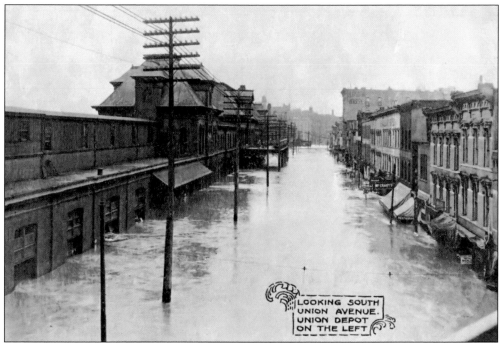

On May 30, 1903, the worst flooding to date in the history of Kansas City began. Two hundred died and 20,000 were left homeless in Kansas City, Missouri, and Kansas City, Kansas. This photograph shows the flooding on Union Avenue, with Union Depot on the left.

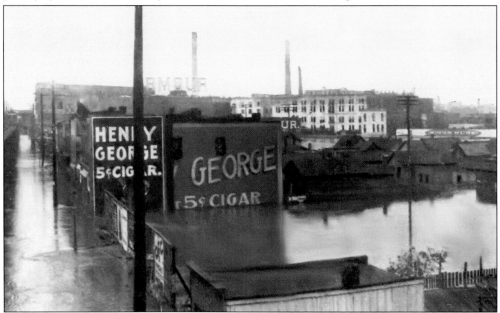

In May and June 1908, Kansas City was flooded again. This time no lives were lost, but property damage was placed at $1 million. After the flood, the Commercial Club and city leaders begged photographers not to produce souvenir postcards and booklets like they did in 1903, as it was scaring away manufacturers. This postcard of a flooded Ninth Street in 1908 shows that they did not listen.

On December 31, 1900, Kansas City held a Century Ball at Convention Hall to ring in the new century, and thousands of people danced the night away to the live music of H.O. Wheeler's Third Regiment Orchestra. Mayor James A. Reed wrote a letter at the ball that was placed in a time capsule to be read by Kansas City's mayor in the year 2000. When Mayor Kay Barnes read the letter 100 years later, everybody laughed when they heard it begin, "Dear Sir."

Members of the Theatrical Stage Employees, Local 31, stand between the marble pillars that graced one of their many places of employment, the Orpheum Theater, a vaudeville house opened by Martin Lehman in 1898. Martin Lehman and the Orpheum were known for creating stars. Harry Houdini was one of many world-famous performers who worked with Martin in Kansas City.

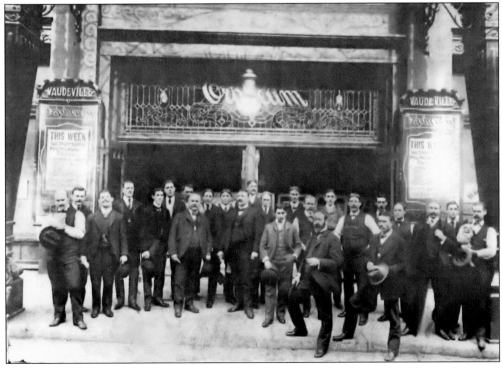

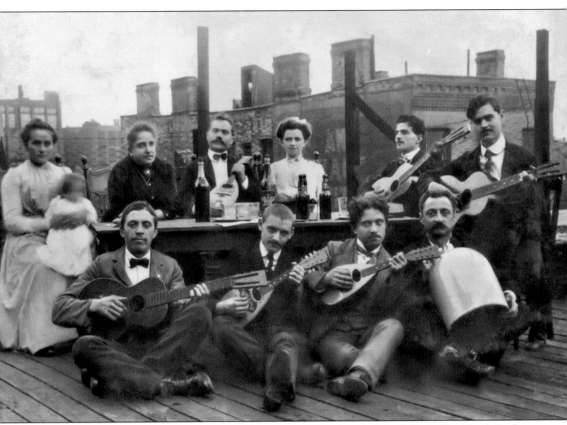

Italian immigrants celebrate with wine and music atop a roof in the North End. The North End, as the River Market area was called once the streets were graded and the business district moved south, was extremely diverse with regard to the race and nationality of its residents and merchants.

Men are window-shopping for hats along Walnut Street. A sign nearby for the Stag Hotel advertises plain baths for 25¢ and Turkish baths "with room" for 75¢. The ad on the waste bin advertises for German American Doctors who "can cure you."

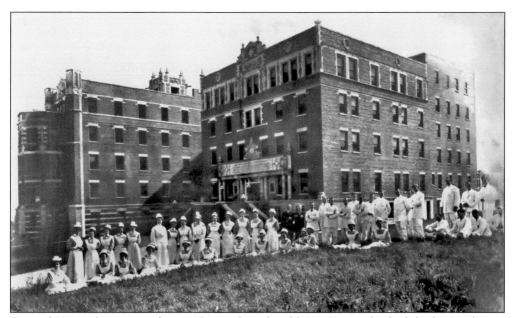

General Hospital was opened in 1905 to replace the old City Hospital, which had existed since 1877. Kansas City was one of the first municipalities to provide free health care to its citizens. The work continues today at the Truman Medical Center on Hospital Hill. (Truman Medical Center Archive.)

Dr. Thomas C. Unthank came to Kansas City with a medical degree in 1898 and by 1908 was one of the best known physicians in town. He spent many years crusading for a municipal hospital to serve the African American community, which could not get care in the white hospitals, and when the General Hospital seen above was left behind in 1908 for a bigger, newer structure, Dr. Unthank worked tirelessly to have this hospital designated as the city's "Negro Hospital," one of the first of its kind in the United States.

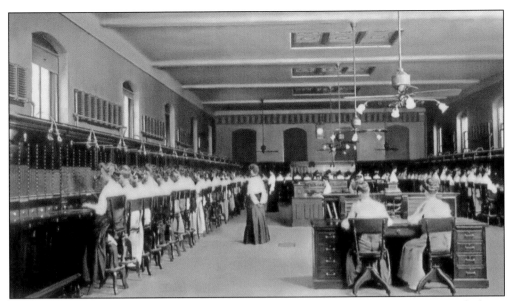

At the turn of the 20th century, Kansas City had two telephone companies, the Home Telephone Company and Bell Telephone, known as "Main," which led to much confusion throughout the city. Most merchants used both services and tried to get the same phone number for each. The "hello girls" who worked the switchboards at the Home Telephone Company earned about $30 a month. The two companies would be combined in 1919.

This picture, called "Photo from Life, by Curtiss" was published in *Kings and Queens of the Range*, a monthly that was published from the Stockyards. The outcry over the poor newspaper boy carrying the *Kansas City Star* caused the Humane Society to hold a mass meeting and fundraiser. Not surprisingly, the top donor to the fundraiser was the *Kansas City Star*.

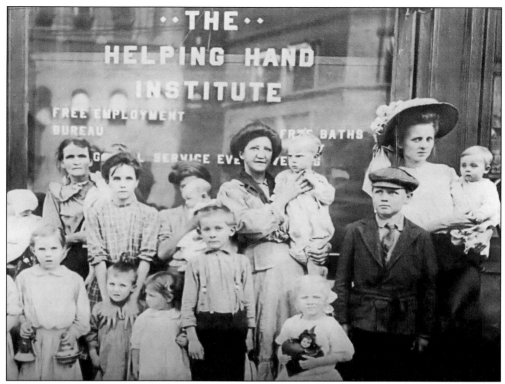

The Helping Hand Institute was founded in 1894 to provide food, shelter, and work to Kansas City's homeless and poor. Men could earn room and board by breaking rocks in the limestone quarries, and free clothing was provided for men who were looking for work and a fresh start. (Goodwill of Western Missouri and Eastern Kansas.)

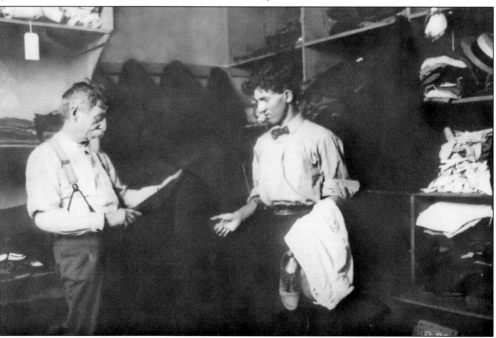

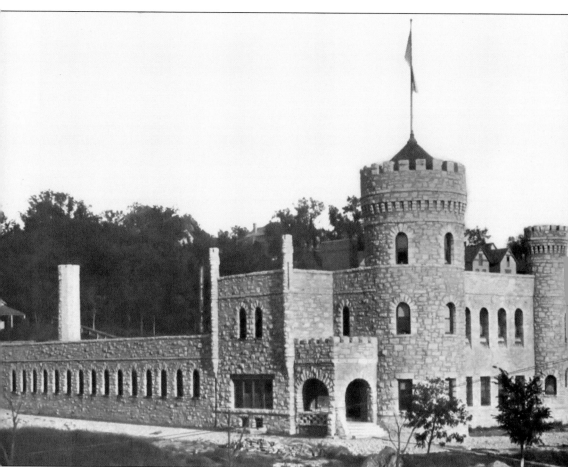

The Vine Street Workhouse was Kansas City's jail. The city could afford to build a castle for prisoners in 1897 because the limestone for the building was quarried on site by the prisoners who would occupy it. Life in the workhouse depended a lot on who you knew. Prisoners with connections had easy access to alcohol and narcotics, women, even the keys to the jail. Others did not fare so well, being locked in the overcrowded, vermin-ridden dungeon of the dreary castle for weeks at a time with little to eat. When the corruption at the workhouse became too much to overlook, Mayor Thomas T. Crittenden Jr. in 1909 gave the newly formed Board of Pardons and Paroles broad authority to investigate workhouse conditions and to parole prisoners based on their individual circumstances. In 1911, the Parole Board succeeded in shutting down the workhouse for good, replacing it with a working farm in the Leeds area. The Vine Street Workhouse still stands today, an abandoned curiosity enjoyed mostly by local photographers.

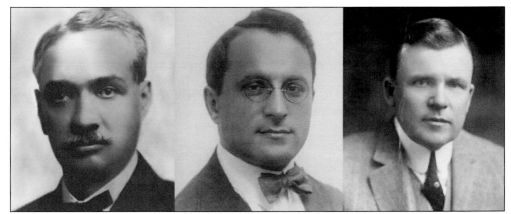

The Board of Pardons and Paroles consisted of, from left to right, William Volker, Jacob Billikopf, and Frank P. Walsh. Their work was so successful that it was copied in cities across America. The board would evolve into the Board of Public Welfare, the first of its kind in the country. Volker would go on to donate millions of dollars to Kansas City charities, including the land that became UMKC. Billikopf became a close friend of Albert Einstein. He and Walsh would later move to the east coast and devote their careers to labor arbitration.

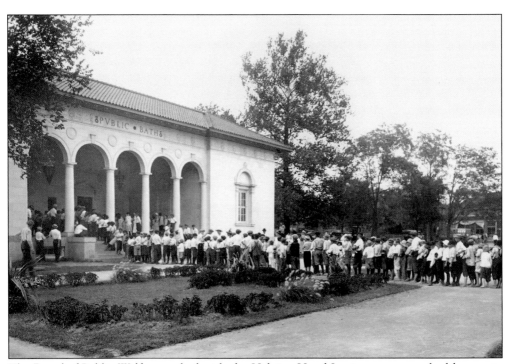

The Board of Public Welfare worked with the Helping Hand Institute to create bathhouses in Kansas City, like the one pictured here. Night schools, free legal aid, loans to the poor, prison reform, and other humanitarian projects made the board so successful that its members were called to cities around America to lecture and consult on setting up similar public welfare services in cities facing the same challenges with poverty and crime.

"Suffer Little Children to Come Unto Me"

St. Anthony's Home for Infants, located on Twenty-third Street between Walrond and College Avenues, was established in 1899 and served as an orphanage for abandoned infants. Children were cared for there until the age of five, at which time the boys were sent to the Kansas City Boys Home at Westport Road and Belleview Avenue, and the girls were sent to the St. Joseph Orphan Girls Home. In 1906, the St. Vincent's Maternity Hospital would be added to the facility, with services being provided for unwed mothers. Thousands of babies were adopted out of the orphanage, which operated until 1969. (Below, MVSC.)

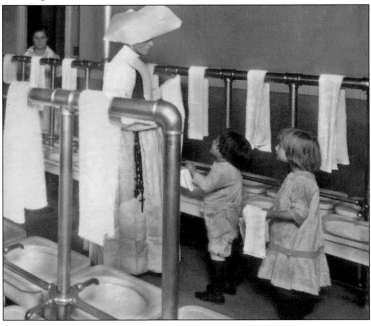

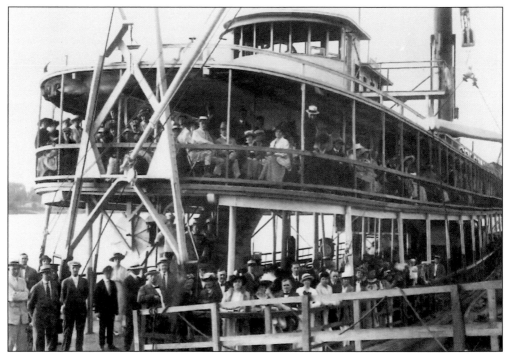

The steamboat *Chester* was an excursion boat during the revival of passenger travel along the Missouri River, making weekly trips to St. Louis. Eventually, the *Chester* would brave Mississippi waters, taking Kansas City passengers to New Orleans. (Al Carlisle.)

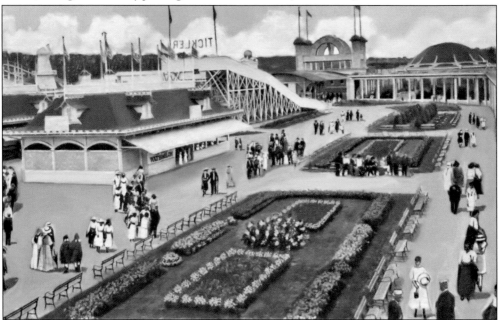

Ferd Heim owned the Kansas City branch of Heim's Brewery and, in 1899, built an amusement park next door. Heim's Electric Park with its beer garden, having fresh beer piped directly from the brewery, was an instant success. The park soon became too small to contain the number of visitors, so in 1907, it was moved to Forty-sixth Street and the Paseo.

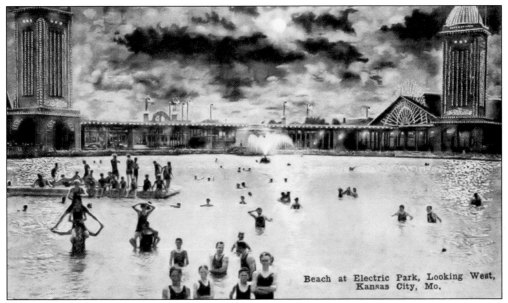

The new Electric Park was even more of a sensation and featured some of the best rides and entertainment to be found in the Midwest, including Hale's Tours. Like Fairmount, it had exquisite lighting, fireworks, and swimming. Unlike Fairmount Park, Electric Park had beer.

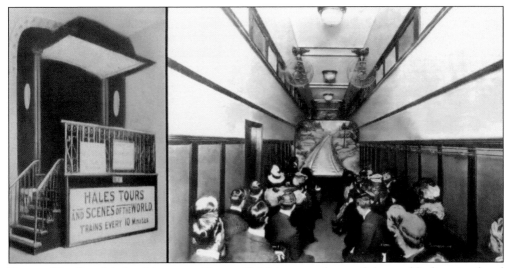

Kansas City fire chief and inventor George C. Hale created one of the world's first simulated theme park rides, made from a train car that would rock and sway while a movie filmed from the front of a moving train played in the front of the car. It debuted at the St. Louis World's Fair in 1904, and by 1907, there were more than 500 Hale's Tours and Scenes of the World rides around the world.

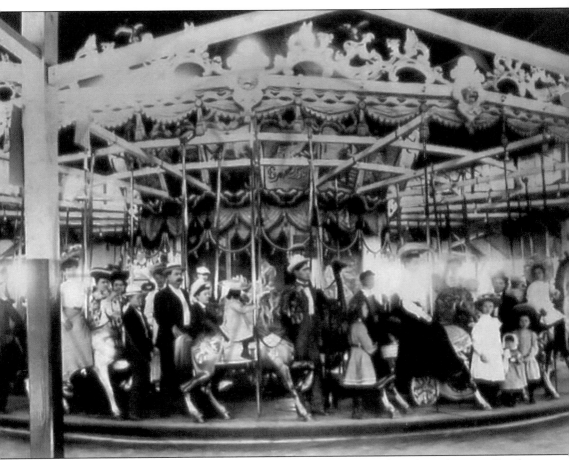

Forest Park operated from 1903 to 1913, located at Independence and Hardesty Avenues. Besides this $15,000 carousel, the park featured a scenic railway, laughing gallery, monkey house, live music, picnic grounds, and more concessions and entertainment.

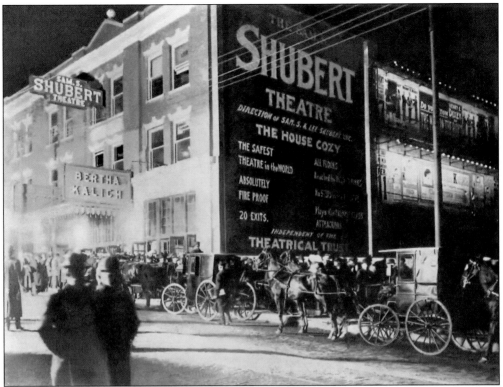

The Samuel S. Shubert Theatre opened its doors in 1906. It was located at Tenth Street and Baltimore Avenue. Named after a Shubert family member who had recently passed away, it was one of more than 100 Shubert Theatres nationwide and featured top music and theatrical acts before being converted into a movie theater.

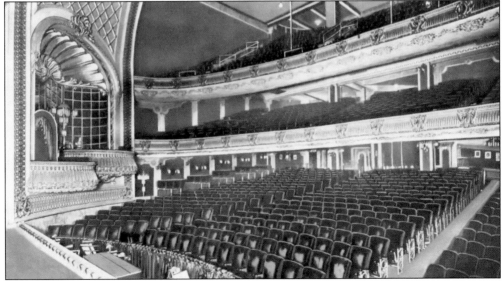

Seating at the Shubert Theatre, which boasted of being fireproof, featured upholstered chairs—700 on the main floor, 415 in the gallery, and 450 in the balcony. All seats were reserved during its years as a live theater.

Born and raised in Kansas City, star baseball catcher Johnny Kling led the Chicago Cubs to two World Series victories in 1906 and 1907. His heart belonged to billiards, though, and in 1908, Kling sat out the baseball season to compete in a world championship billiards tournament in Kansas City. He won the tournament, but the Cubs lost the pennant that year. In 1909, Kling returned to his Cubs and took them back to the World Series, although not for a win. Johnny Kling would later retire from baseball and return to Kansas City, opening a world-famous pool hall and billiards academy with his nephew, billiards champion Benny Allen. In 1933, Johnny Kling bought the baseball franchise of the Kansas City Blues, increasing attendance and profits by desegregating the stadium for the first time in the club's existence.

JOHNNY KLING WOULD RATHER PLAY BILLIARDS THAN JOIN THE CUBS

Charles Leslie Johnson was a ragtime composer with more than 300 compositions to his credit. Born in Armourdale in 1876, he lived in the area his entire life. He started his career at J.W. Jenkins and Sons Music store, his first publisher. By 1910, he had sold three million copies of his song "Iola" and would continue selling millions of pieces of sheet music throughout his life.

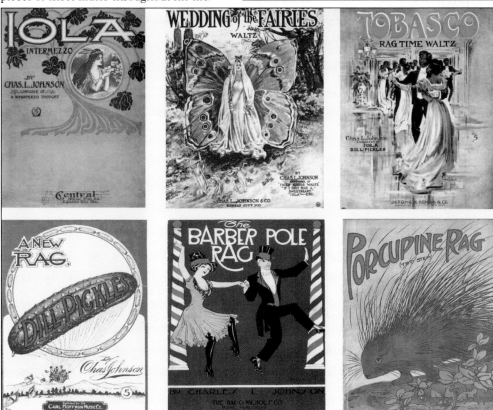

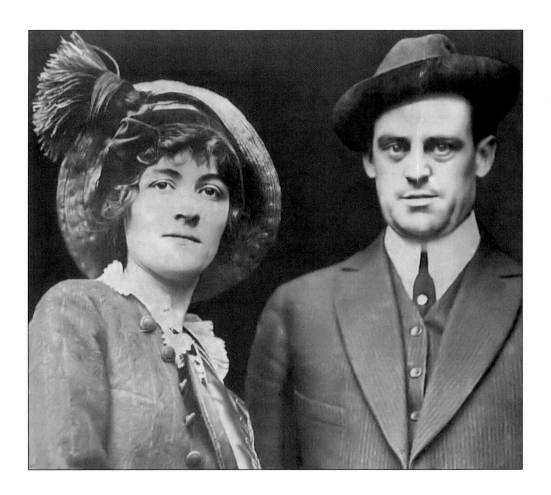

One of the hottest celebrity couples of their time were New York Giants outfielder Mike Donlin and his Kansas City-turned-Broadway actress wife, Mabel Hite. Hite started her career at Fairmount Park and grew famous on Broadway. The World Series champion's alcohol-related injuries took him off the field but onto a successful comedy stage career with his wife. After Mabel died of cancer in 1912, Donlin returned to baseball.

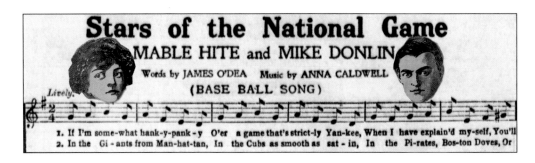

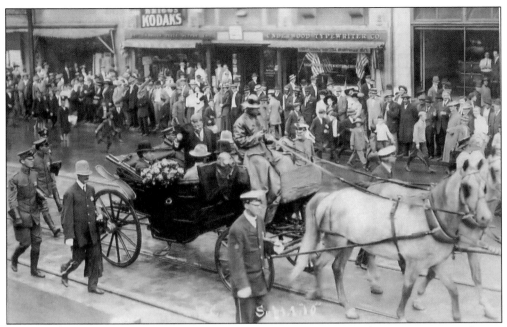

Thousands of residents turned out and stood in the rain on September 1, 1910, to see former president Theodore Roosevelt as he paid a visit to Kansas City. Welcomed by city leaders and Missouri governor Herbert Hadley, Roosevelt's carriage paraded through the streets of the town (shown here on Grand Avenue) before speaking in front of 20,000 people that evening at Convention Hall.

LET UNCLE SAM GET INTO THE GAME.

By Theodore Roosevelt.

Seven years later, former president Roosevelt would join the staff of the *Kansas City Star*, telegraphing exclusive editorials during the World War I era, mostly supporting the war effort and denouncing Pres. Woodrow Wilson as a wimp. Roosevelt wrote more than 100 of these editorials between 1917 and 1919. His own son was killed in July 1918, fighting for the Allies in France.

Herbert Hadley grew up in Olathe and earned a law degree at Northwestern Law School in Chicago before coming back to Kansas City to start a law practice. He became interested in local politics, becoming the first Republican prosecuting attorney in 25 years. After this, he was elected Missouri's attorney general, distinguishing himself by taking on and successfully prosecuting the Standard Oil Company for unfair trade practices. In 1910, he was elected governor of Missouri.

Thomas Hunton Swope moved to Kansas City from Kentucky in 1857, eventually owning more land than anyone in Kansas City. He donated more than 1,000 acres for a city park, which today still bears his name. Swope died mysteriously in 1909, and for the next seven years, the husband of his niece, Dr. Bennett Clark Hyde, would stand trial repeatedly for his murder, eventually having his conviction overturned.

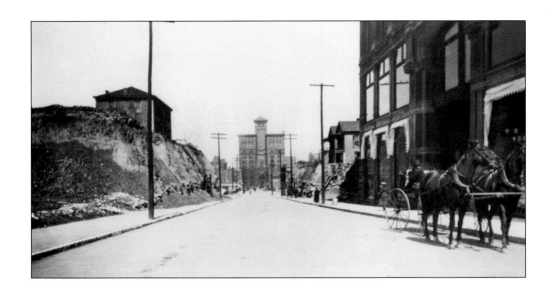

This is the view from Eleventh Street and Baltimore Avenue showing the New York Life Building in the background, as it appeared in the 1880s (above) and 20 years later (below), after the streets had been graded and after City Beautiful had come to fruition.

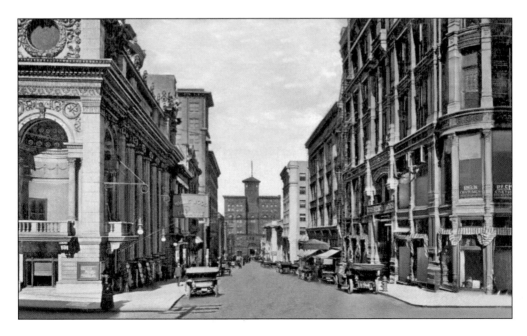

DISCOVER THOUSANDS OF LOCAL HISTORY BOOKS FEATURING MILLIONS OF VINTAGE IMAGES

Arcadia Publishing, the leading local history publisher in the United States, is committed to making history accessible and meaningful through publishing books that celebrate and preserve the heritage of America's people and places.

Find more books like this at
www.arcadiapublishing.com

Search for your hometown history, your old stomping grounds, and even your favorite sports team.